Industrial
and
Technical
Photography

Charles Lee Tucker, Ed.D.

PRENTICE HALL, Englewood Cliffs, New Jersey 07632

LIBRARY OF CONGRESS
Library of Congress Cataloging-in-Publication Data

Tucker, Charles Lee
 Industrial and technical photography / Charles Lee Tucker.
 p. cm.
 Includes bibliographical references and index.
 ISBN 0-13-463456-X
 1. Photography, Industrial. 2. Photography, Commercial.
I. Title.
TR706.T83 1989
778.9'96--dc19 88-9682
 CIP

Editorial/production supervision
 and interior design: **Kathryn Pavelec**
Cover design: **Wanda Lubelska**
Manufacturing buyer: **Bob Anderson**
Page layout: **Steven Frim**

© 1989 by **Prentice-Hall, Inc.**
A Division of Simon & Schuster
Englewood Cliffs, New Jersey 07632

Printed in the United States of America

10 9 8 7 6 5 4 3 2

ISBN 0-13-463456-X

Prentice-Hall International (UK) Limited, *London*
Prentice-Hall of Australia Pty. Limited, *Sydney*
Prentice-Hall Canada Inc., *Toronto*
Prentice-Hall Hispanoamericana, S.A., *Mexico*
Prentice-Hall of India Private Limited, *New Delhi*
Prentice-Hall of Japan, Inc., *Tokyo*
Simon & Schuster Asia Pte. Ltd., *Singapore*
Editora Prentice-Hall do Brasil, Ltda., *Rio de Janeiro*

To:
John, Robert, Heather,
and Trisha

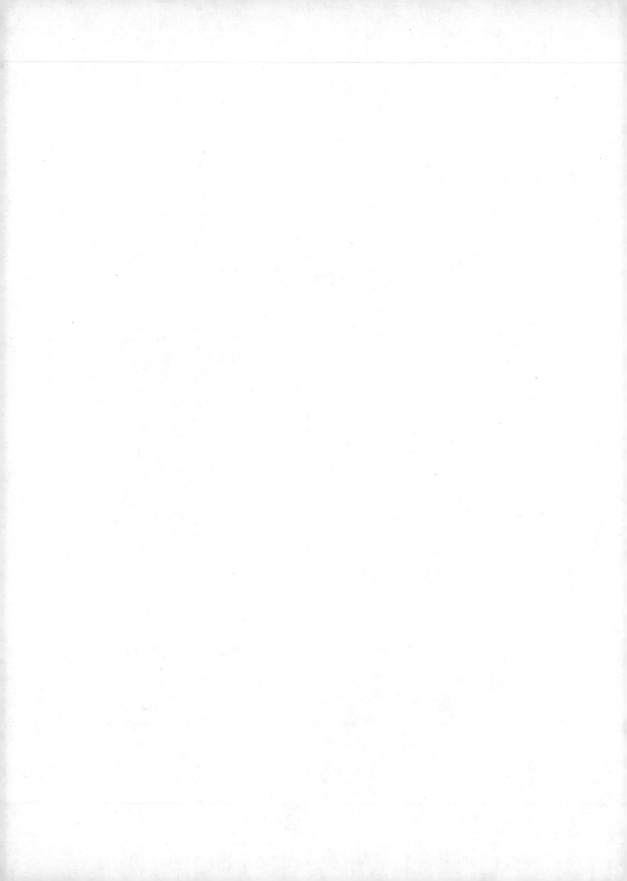

Contents

Chapter 16 **Creativity** 199

Index *222*

LIST OF TABLES

LIST OF ILLUSTRATIONS

Preface

Photography! It is both a science and an art. The science side is slowly being lost to automation—in equipment, and in the pre-mixing of chemicals to a pour-and-stir concept. Certainly both concepts are a boon to the professional photographer who makes money behind the camera. The art side is of prime importance in that the image is what the public sees, not the process.

Industrial photography has often been misunderstood by the average photographer, mainly because it occurs behind the closed doors of business secrecy. Industrial photography requires that the photographer be not only a skilled technician, but also an accomplished visual artist, a diplomat, and a public relations expert; in other words, a jack of all trades.

This book evolved from teaching Industrial Photography courses and from the pursuit of higher-education degrees for the past ten years. In other forms, the chapter on creativity was my Master's paper and the entire book was the basis for my Doctoral Project.

Each chapter is the basis for one or two assignments. In each, I have tried to give the necessary background information, as well as any relevant technical information, to accomplish the assignment. The book is not intended to teach the basics of photography (exposure/development/printing). Invariably, I have left out specific step-by-step cookbook approaches, believing that photographers must size up the options on location, select the necessary equipment that may be at their disposal, and create an image of meaningful importance.

The book is illustrated with a variety of images. Each image was approached by the photographer based on the needs of the client or the assignment. When

reading, refer to the images to see how they relate to the concept being discussed in the text.

ACKNOWLEDGMENTS

I wish to thank the many authors and photographers who have added to my storehouse of knowledge that has enabled me to produce this book. I have done my best to include these persons in the references and to acknowledge all. Forgive me if I have omitted someone.

I wish especially to thank my many students who have lent their ideas, and Mr. John Kommelter and Ms. Darcie Eggers for their excellent darkroom work, sorting, and ideas.

I also wish to thank Martin Marietta Energy Systems for releasing much of the work that I have done for them at the Oak Ridge National Laboratories in Oak Ridge, Tennessee. My thanks also go to the following individuals in the Photo Department: Ward Bandy, Bill Norris, Jim Richmond, and the photographers and darkroom staff at both X-10 and Y-12. I also wish to thank Mr. Ed Aebisher and Mr. Steven Wyatt of the Public Relations Office for their help in selecting and clearing the photographs.

Thanks to all the photographers who contributed to the book. Each photo is acknowledged with the name of the photographer. If there is no credit, the author is responsible.

My thanks to the Association for Educational Communications and Technology for permission to use the section ''AECT Standards'' in Chapter 15.

CHARLES LEE TUCKER, ED.D.

Industrial
and
Technical
Photography

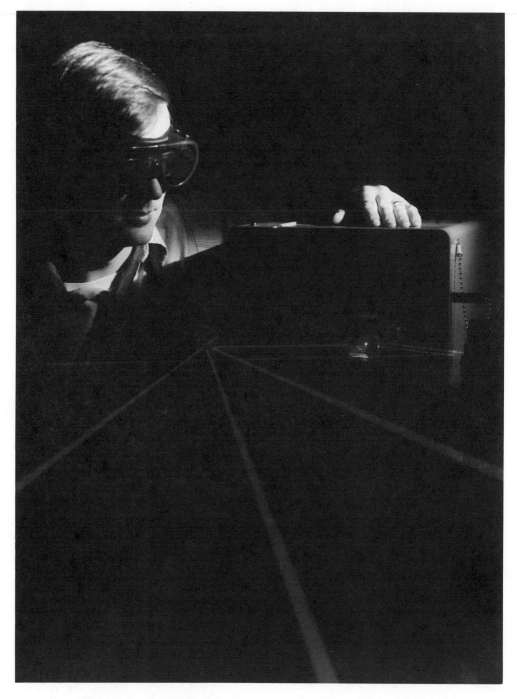

Photo 1.1 Industrial and technical photography includes not only traditional photography, but also futuristic images such as laser beams. (Courtesy of Oak Ridge National Laboratories.)

Chapter 1

Introduction

Industrial and technical photography is such a broad subject that it would take many books to cover every aspect, if indeed it could be done. This book covers basic to intermediate topics of concern to the average industrial photographer. This is not to imply that all industrial photographers will photograph aerials or exploded views. Each company will have its own demands as to the type of photography that is required. The book is also aimed toward the amateur photographer and the studio owner who wish to know more about the world of industrial photography, especially concerning what is required on individual assignments. Readers will quickly see from the range of material discussed that the industrial photographer must be adept in many areas of photography.

Since the nature of the work is so varied, specific guidance as to brands of equipment or the technical aspects of equipment operation has not been included. Rather, you will find general and specific photographic principles which can be applied to any equipment. We do assume a general knowledge of processing and printing fundamentals. Any readers who need to polish these skills are referred to the many very good basic texts available concerning these topics.

THE INDUSTRIAL FIELD

To be an industrial photographer is to provide photography for use by industries. The photographer is usually on the payroll of a company, although many commercial photographers have some industrial accounts. The field includes such diverse areas

as medicine, government, education, and the military as well as the traditional manufacturing industries. The image of the industrial photographer taking pictures in grimy foundries is no longer the norm. The high-tech environment of the 1980s has made its mark, and today's industrial photographer is often seen clothed in a "clean suit" in a special atmosphere, photographing some exotic process. According to the *Occupational Outlook Handbook,*[2] the industrial field will grow faster than most other fields through the 1990s, especially in the scientific, engineering, medical, and entertainment areas. (Superior numbers refer to end-of-chapter lists of references.)

The industrial photographic field requires more skill and more diversification than does any other photographic area. The varied conditions that the photographer faces and the many uses for the photographic images that he or she creates challenge the imagination. The photographer must be adept at lab work; at lighting many different products and textures under difficult location or studio conditions; at working with a variety of people, from executives to laborers; and at being able to communicate in both a visual and a verbal sense. Many may find that their skills

Photo 1.2 *The industrial photographer may be required to use specialized clothing, techniques, and equipment to photograph exotic processes in special atmospheres such as this one of a moon box. (Courtesy of Oak Ridge National Laboratories.)*

will extend into the video arena, or into motion pictures, both conventional and high-speed. The range of specialization is enormous: metallography, x-ray photography, electron microscopy, multimedia presentations, instrumentation photography, holography, infrared and ultraviolet photography, Schlieren photography, police and criminal investigations, medical photography—the list is long and varied.

INDUSTRIAL PHOTOGRAPHIC USES

There are many uses for the photographic image within industry. The following list shows some of the varied uses, ranging from administration to testing.[1]

Administration. Photographic use in this area includes annual reports, construction or project reports, various control charts, microfilming and computer imaging, decor photographs for buildings, executive briefings, insurance documentation, inventory, time- and motion studies, and plant surveys.

Photo 1.3 Project reports to management can be effectively illustrated with photography. (Courtesy of Oak Ridge National Laboratories.)

Advertising. Included in this area are advertising and catalog illustration, dealer publications, customer brochures and pamphlets, direct-mail ads, displays, exhibits, instruction manuals, packaging, promotional films, and video.

Distribution. Areas of greatest interest here are damaged shipments and records, material and personnel flow, inventory controls, loading procedures, materials handling, packing and loading, and traffic studies.

Industrial Relations. This category includes such topics as accident reports, OSHA reports, employee continuing education and training, ID photos, health and medical photos, radiographs, employee orientation, safety training and posters, personnel records, and personnel recognition.

Plant Engineering. Included here are aerial surveys, construction, industrial engineering studies, infrared heat control, machine setup studies, methods analysis, inspection reports, piping and wiring layouts, plant layouts, training media, and maintenance reports.

Plant Security. Items of interest here are ID cards, infrared detection, courtroom evidence, surveillance, and specialized criminalistic photographic work.

Photo 1.4 *Construction photos can be used for industrial engineering studies.*

Product Research and Development. Areas of concern include consumer testing, test setup documentation, field tests, instrument readings, oscillography, patent documentation, performance studies, pilot models, proposals, styling, wear and stress studies, autoradiography, bubble chamber photos, electron diffraction, electron microscopy, high-speed motion pictures, microphotography, macrophotography, nuclear photography, photomicrography, seismography, spectrography, stereography, and x-ray diffraction studies.

Production. This area deals with assembly photos, methods studies, nameplates, packing records, photo drawings, shadowgraphs, silk screening, and work methods.

Public Relations. Important activities here include annual reports, biographies, publicity, stockholder reports, and news releases.

Purchasing. Items important to purchasing include component selection, damaged part identification, and documentation of specifications.

Photo 1.5 *Pilot model of high-temperature-materials lab. (Courtesy of Oak Ridge National Laboratories.)*

Photo 1.6 *Photographs of personnel are used for public relations purposes, such as this photograph of an employee using a scanning electron microscope. (Courtesy of Oak Ridge National Laboratories.)*

Sales. In this category are catalog illustrations, equipment demonstrations, newsletters, calling cards, pricing illustrations, product portfolios, product proposals, and sales training.

Service. Service areas comprise failure studies, installations, line art, manuals, parts lists, photocopy, and training aids.

Testing. Areas of concern are high-speed photography, metallography, oscillography, performance testing, reports, and standards.

Many more areas could be listed, but it should be clear how wide the scope of industrial photography actually is.

Photo 1.7 *This photograph of a broken wire was used in a failure study report. (Courtesy of Oak Ridge National Laboratories.)*

REFERENCES

1. Kodak (date unknown). *Photo-Process Audit*, pp. 7–100. Rochester, N.Y.: Eastman Kodak.
2. U.S. Government (1986–87 edition). *Occupational Outlook Handbook*. Washington, D.C.: U.S. Government Printing Office.

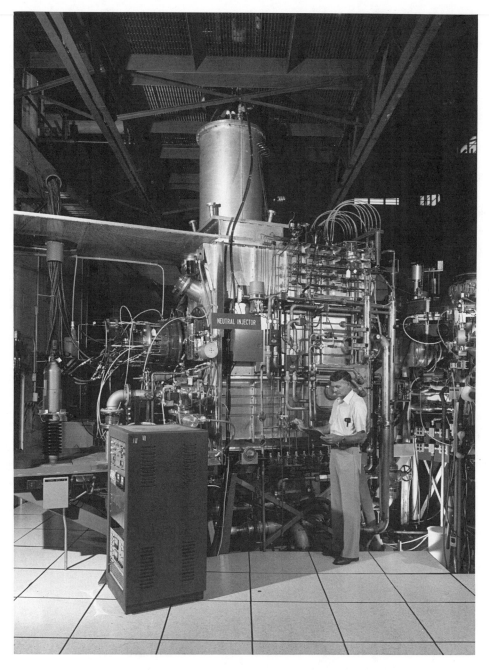

Photo 2.1 Stock images, such as this photo of fusion energy research and development, can be used in many markets for various uses. (Courtesy of Oak Ridge National Laboratories.)

Chapter 2

Marketing

OBJECTIVES

Upon completion of this chapter, you should be able to:

- Identify the importance of the portfolio.
- Identify several potential clients in the industrial area.
- Identify several uses or market areas for photography in the industrial area.
- List several areas of concern to improve the usefulness of an in-house photographer.
- Understand the concept of stock photography.
- Identify various legal issues facing the industrial photographer.

INTRODUCTION

The market in the industrial area is tremendous for the freelancer and the established commercial photographer who wish to increase their work. There are many small businesses that cannot justify a full-time photographer on the payroll, but need photographic work performed periodically. Ideas for additional, specific markets are found in the "uses" section of the various chapters. Other ideas for markets are to be found monthly in such trade publications as *Rangefinder, Professional Photog-*

Photo 2.2 *Historical sites need photography for brochures and preservation purposes.*

rapher, and *Studio Photography*. The serious photographer would do well to read books on résumés, self-promotion, and portfolio construction. Check with libraries and stores for their location.

THE PORTFOLIO

One aspect of marketing that is usually uppermost in each photographer's mind is his or her portfolio, called by some a "book." It is a showcase of your work that shows your potential to the client. It is a well-known fact that you will get the jobs that are illustrated in your portfolio. If you go for architecture assignments and have only portraits in your portfolio, the client will not accept you as a photographer of architecture. The point is: Go out and photograph the subjects found in this book. This will provide a good start on a general industrial portfolio that will sell your abilities to an industrial client. Try to show versatility and variety in your portfolio. Industrial photography is varied. Show photographs that illustrate ideas and communicate concepts rather than just snapshots showing that you were there.

Photo 2.3 *Images of people at work are often used in annual reports. (Courtesy of Oak Ridge National Laboratories.)*

The portfolio is your main selling tool and it should be of the highest-quality workmanship. Review it regularly. Replace defective or damaged pieces, and update it often to replace out-of-date styles. The old saying that ''you are only as good as your last photo'' says a lot. Keep up to date on trends and styles by looking at trade magazines in the target area in which you desire to work. Selling your abilities might also include advertising, mailings, posters, self-publicity, and, of course, sales calls to potential clients.

Many in the corporate/industrial area seem to think that the annual report should be the main item of focus. Granted that it is a glamorous assignment for the photographer and certainly looks good in one's portfolio, but there are very few such jobs around. An annual report is published only once a year, and the competition is great. There are many other markets in which to secure work, providing steady, year-round income, on which the newcomer should concentrate. These include brochures, booklets, calendars, posters, postcards, audiovisual material, public relations and publicity work, in-house magazines, and personnel photography. The list could go on.

The way you present your portfolio will have a bearing on whether you get an assignment. The portfolio must be well presented, clean, neat, and uniform. Pay

Photo 2.4 *Don't overlook small-business clients as potential sources for photography.*

attention to the smallest detail. There is no "one" way or format for a portfolio. There is even evidence of a trend toward video portfolios. But whether you present slides, prints, tearsheets, or video, it must be professional.

POTENTIAL CLIENTS

Clients can come from many areas. Check the local chamber of commerce. Check the signs at building sites for the names of architects, builders, developers, and leasors. Check small-business associations. Sources of possible clients are limited only by your imagination. Send a letter of introduction, stating your qualifications, and follow up with a personal phone call or visit to show your portfolio. Although you may not get work immediately, you have planted a seed and may well get calls for work on future projects.

One difficulty in discussing potential clients is that the industry is so diversified. Clients could include:

The military	Law enforcement
Science centers	Medical facilities
Educational centers	Manufacturing industries
Government agencies	Virtually all businesses

Photo 2.5 *Many small businesses need catalog photography showing product details.*

Markets or uses for photography in these businesses include:

Advertising	Documentation
Research	Displays
Exhibits	Decor
Training	Investment
Quality control	Research and development
Surveillance	Communications

A complete list is impossible, because of the many uses that photography has. There are literally thousands of markets. Many of the specialized uses within industry are listed in Chapter 1. The limit is only on yourself to sell the photography to the client. In many cases the client has not realized a need for the photography, and it is up to you to show them how it can be used.

Photo 2.6 *High-tech images of lasers have potential for use in many areas. (Courtesy of Oak Ridge National Laboratories.)*

IN-HOUSE MARKETING

As a freelancer you are marketing yourself and your services on a daily basis. It is all too common for in-house photographers to forget that they must also market their services to management if their positions are to be secure. There are several things that in-house photographers can do to enhance their value to their employers.

First, continuing education is a must. The techniques in the field of photography are changing daily. New equipment, processes, and applications are being developed every day. Read the trade journals, as these advise on changes in an efficient and timely manner. Attend conventions; they provide contact with peers and provide other points of view that could be useful. Enter print competitions—not so much to win awards, but to see how your peers view your work.

Within the company you must promote yourself and the services that you can provide. Try to be involved with projects from the beginning. This will allow input from you on what role photography could or should play. Know the decision makers in the company and inform them when you hang a print or publish an article. Try

Photo 2.7 *Scenics can be used on walls as decor in industry.*
(Courtesy of Oak Ridge National Laboratories.)

to keep your name in the forefront as the photographic professional. If they start turning to secretaries or other personnel to do photography work, it is a sure sign that your position is in trouble. If you promise work, by all means be able to deliver it. The bottom line is profit. If you cannot provide a service to the company in such a manner as to produce a profit, it will not be long before management will contract out the work and close the department.

STOCK PHOTOGRAPHS

There is one area of potential income in the industrial area that is generally overlooked—stock photography. Basically, you take upon yourself the task of creating a stock of images on speculation and market them to clients. There are many stock houses that will market the images for you for various percentage fees, or you could try to market them yourself. It takes many letters and queries to companies to build a list of clients, and it takes many hours to keep these contacts buying from you.

One reason that more industries are going to stock images is the increasing cost of sending out a photographer or creating an original set in a studio. The client can pick up a phone, tell a stock house to send 20 to 40 images of whatever, and the next day, in the office, be able to pick an image to use from the work of a variety of photographers. The client saves money, gets top-quality professional work, and

Photo 2.8 *General views of industry are needed in stock files and as a historical perspective for a company. (Courtesy of Paul A. Knowles.)*

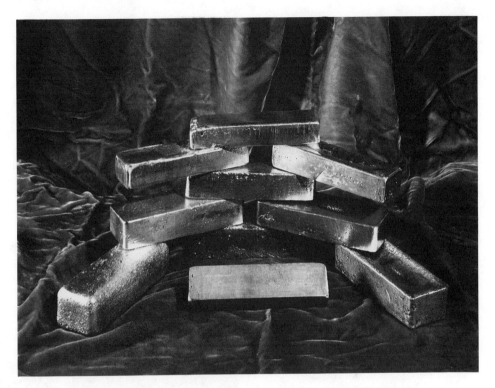

Photo 2.9 *Silver bars illustrate cost-cutting measures being taken by recovering silver from photographic processes. (Courtesy of Oak Ridge National Laboratories.)*

does not have the hassle of viewing the portfolios of a number of photographers, none of whom may have the needed image on hand.

One aspect for the photographer to consider is the agency and the terms to agree upon. Generally, the agency does the advertising, cultivates the clients, markets your images, and creates multiple sales of images for you, for a fee. However, for them to do this, you must submit a lot of professional work. Generally, the agency can command a higher fee than an individual photographer could. The agency also handles the selling of "rights," which keeps the photographer from having to hassle with clients and lawyers. A list of stock agencies can be found in the *ASMP Stock Photography Handbook*.[1]

LEGAL CONSIDERATIONS

The sale of any image can be a complicated matter. Many industrial photographers work under the "work for hire" rule. This means that for a flat fee to you, the client

gets all photographs, negatives, and so on, and is able to use these as he or she wishes, as many times as desired. This irritates many photographers, who would like to resell their images to other clients for additional income. The "rights" issue is constantly evolving and changing, especially in light of the new copyright law. The legal aspects of the law are still being tested in the courts. No single answer is right for everyone. You must negotiate the rights you intend to sell before any work is done. You must get it in writing before any work is done, and then you can feel somewhat safe in knowing that if an image is misused, you have the right to sue, which may drag out in court for years.

The ASMP publishes a guide for freelancers and a legal guide that discusses copyright, sales, and rights that will be of concern for the nonstaff photographer. The Professional Photographers of America have programs for their members that protect and assist them in the case of lawsuits, and they advise members on copyright matters.

There is also the problem of privacy and the question of model releases. The adage "If in doubt, get a release" is appropriate advice. The photographer usually has the right to photograph but may not have the right to publish or sell the work. A lawyer familiar with copyright and publishing laws may be a good resource to call on if you have any questions in this area.

Photo 2.10 *Photos with recognizable features need model releases. (Courtesy of Rod Hop.)*

TABLE 2.1 PHOTOGRAPHIC ORGANIZATIONS

Advertising Photographers of America (APA)
823 North LaBrea Avenue
Los Angeles, CA 90038

American Society of Magazine Photographers (ASMP)
205 Lexington Avenue
New York, NY 10016

Associated Photographers International (API)
21822 Sherman Way
Canoga Park, CA 91303

Association for Educational Communications and Technology (AECT)
1126 16th Street NW
Washington, DC 20036

Professional Photographers of America (PPA)
1090 Executive Way
Des Plaines, IL 60018

SUMMARY

The marketing strategy of a photographer may well determine his or her future. Plan well, in advance, and if signing contracts, spell out everything before doing any work. Be careful when selling rights and be aware of the need for model releases. Check with the various publications mentioned above and the organizations listed in Table 2.1 for membership details and benefits offered.

REFERENCE

1. American Society of Magazine Photographers. *ASMP Stock Photography Handbook*. New York: ASMP.

Photo 3.1 Holifield heavy ion research facility construction. (Courtesy of Oak Ridge National Laboratories.)

Chapter 3

Construction

OBJECTIVES

Upon completion of this chapter, you should be able to:

- List various uses for construction photography.
- List sources of potential clients.
- Explain why it is important to scout an area.
- Explain which camera format is used.
- Explain safety precautions.

INTRODUCTION

Ever since Samuel F. B. Morse brought photography to this country in 1839, cameras have been used to record the growth and construction activities of industry. Activities such as lumbering, oil exploration, and the opening of the west by the railroads provided scenes for the cameras. An important aspect of industry is recording its changes with photography. From 1900 to the 1920s, images of assembly lines, automobiles, and airplanes delighted the public. Henry Ford's business was one of the first to keep a visual record of its activities. This was to show the public what the firm did and why it was important to the community. This was, in a sense, a version of the modern-day annual report.

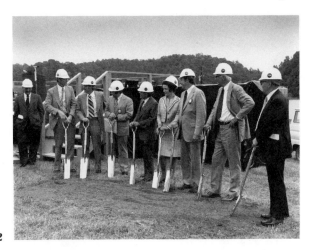

Photo 3.2

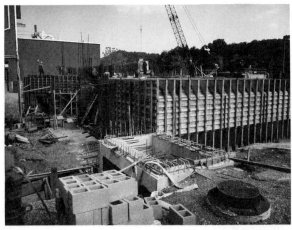

Photo 3.3

A series of photographs from
ground breaking to finished
project can be used for publicity.
(Courtesy of Oak Ridge National
Laboratories.)

Photo 3.4

USES

The documenting of industrial expansion via photography has many uses. Obviously, one is to show the progress of a building or construction project. These types of photographs can be used in annual reports to show stockholders where profits are being spent. News releases with photographs provide positive publicity for a company and many trade magazines use such photos in articles.

Many contractors need photography to show potential clients the quality of their work, and possibly more important, to provide a record of disputed items for possible court litigation. Documentation is vital to prove that construction plans were followed. Photographs provide a record of wiring and pipe layouts that will later be inaccessible. A reference for later improvements can save considerable money: for example, if you have to dig up a concrete floor to tap into a drain but you do not know on which side of the room it was run.

It is often necessary to keep the top executives informed of the progress of building projects via photography. A good, detailed photograph often saves pages

Photo 3.5 *This photograph of the Lyons, Kansas nuclear waste project shows the construction layout, which will later be covered over and thus not visible. (Courtesy of Oak Ridge National Laboratories.)*

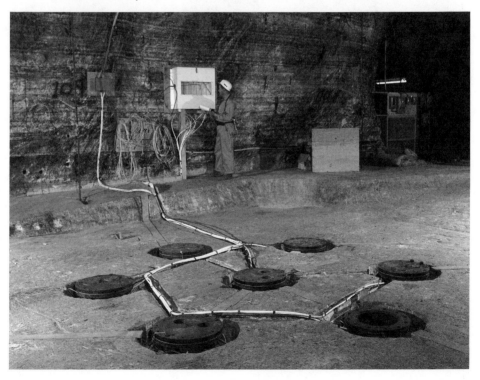

Photo 3.6 *Contractors need photographs of their installations.*

of written reports. Such photos may be used for engineering studies and by training departments to train new workers in construction methods.

In most communities, contractors abound. Public projects, such as sewer work, public improvements, and parking garages, are generally numerous throughout the year. Local planning boards and zoning commissions and building permit offices are good places to look for information on projects. Minority contractors need good photographic records to qualify for government projects. In addition, the private sector abounds with factories, apartment complexes, houses, and shopping centers, all potential clients. Not only do these clients need photography from ground-breaking through the progress of the building, but a finished illustrative architectural view is often appropriate.

Be sure to photograph the decorations in furnished models of condos and apartments. This could lead to additional sales to interior decorators and designers, and

Photo 3.7 *Photograph of a heat pump for a contractor.*

to landscape designers and contractors. The community sections of newspapers look for stories and photographs on new activities in the community, which could provide a source of income, and quite often workers will purchase photographs of themselves on the job. While documenting the normal construction activities, the photographer should look for pictorial shots, silhouettes, and so on, that lend themselves to graphic design, and unusual events that could be used in other areas.

TOOLS

Usually, 120 format cameras work well for this type of coverage. However, the photographer should obtain clear, straightforward, undistorted views. Keep small cameras as level as possible to prevent distortion. Use a tripod. More photographs are ruined by camera shake than for any other reason. If perspective control is necessary, a view camera is a logical choice. For the final illustrative views, a view camera should be considered because of its high quality.

Photo 3.8 *Portable lighting may be needed to illuminate interior views.*

TECHNIQUES

On planning any photographic coverage on a construction site, you need first to determine what the requirements of your client or company might be. Discuss various ideas so that there are no misunderstandings. Scout the location in advance so that you bring the necessary equipment. Locate the view points required, so that you do not have to carry a lot of equipment unnecessarily. Determine the lens selection for the site and whether lighting will be needed for the interiors.

Remember to check for electricity on the site. You may have to use portable strobes to fill the shadows. While scouting, you should check with the foreman to determine if any special processes, such as concrete pours, are taking place and when they are scheduled. The more informed the photographer is, the more rapidly and safely the actual photography will take place.

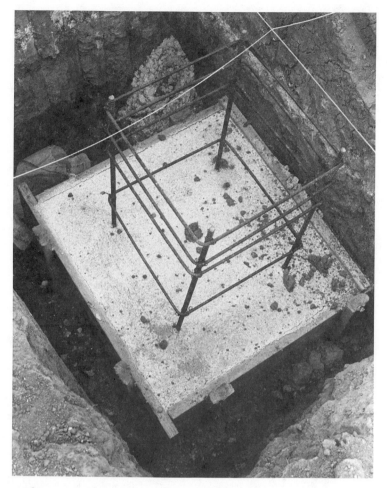

Photo 3.9 *Photograph details of construction, such as concrete pours, as they happen. (Courtesy of Mark Jenkins.)*

When photographing construction progress reports, the same view points should be used for the weekly or monthly series, to provide continuity for comparison.

While roaming around the site, remember *safety*. Hard hats, shoes with steel shanks and toes, and safety glasses are lifesavers. Use them. Do not disrupt construction activities. This causes photographers to be unwelcome on a site, and help may be needed later from the foreman, supervisors, or workers. Remember, for insurance reasons, first get permission to enter a construction site.

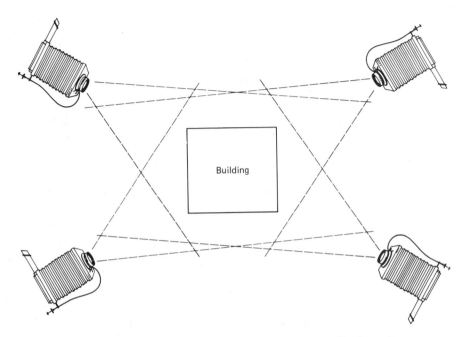

Diagram 3.1 Construction coverage. Generally, it will take only four photographs to cover all sides of a building. Use the same spots on a continuing basis.

Photo 3.10 The high angle of view of this waste storage tank construction is an advantage in illustrating the site. (Courtesy of Oak Ridge National Laboratories.)

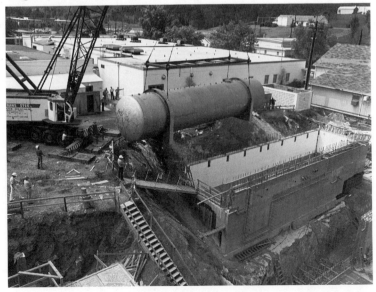

SUMMARY

Construction photography is a fascinating area to pursue, is potentially profitable, and can be pictorially creative if the photographer opens his or her eyes. Construction photographs can be taken as a challenge to form a unique style. The uses of this type of photography are endless, limited only by the imagination and determination of the photographer. The equipment needed is limited compared to studio needs. However, the quality of images is just as important as for other photographic applications.

Photo 4.1 Environmental Science Division Building, Oak Ridge. (Courtesy of Oak Ridge National Laboratories.)

<div align="center">

Chapter 4

Architecture

</div>

OBJECTIVES

Upon completion of this chapter, you should be able to:

- List various applications of architectural photography.
- List the equipment needs of an architectural photographer.
- Explain why filters are important and describe their uses.
- Explain an ''approach'' to architectural photography including composition and lighting.
- List types of special effects.
- List film types needed for night architectural photography.
- Explain the double-exposure method of night architectural photography.

INTRODUCTION

Photographing architecture is by no means a simple task. To some, though, it is merely a job of recording the exterior shell of a building. Photography should underscore what the architect wanted to express in the design. To be a success, an architectural photograph should convey the essence of the building; it should not dominate the architecture. The photographer must be aware of the design elements to be able to compose an interpretive photograph. The photographer should be concerned with capturing the rendition of shapes, lines, tones, and textures. Hopefully, the viewer will become involved in the architecture.

Photo 4.2 *Home and garden magazines publish interiors to promote higher standards of living.*

USES

There are many uses for architectural photography other than merely to record a building. Architects and designers need photographic samples of their work to promote their business. The features and character of a building should be expressed in this type of photograph. Builders need samples to show the quality of their craftsmanship. Architectural photographs have many uses in trade magazines and books. Advertising agencies need photos to illustrate advertisements seeking occupants for office complexes. Interior photos may be used in promotions by equipment dealers or makers of materials. Home and garden magazines publish a large amount of photography illustrating ideas about better homes and higher standards of living. Exterior photos of the landscape may be used by designers to promote their businesses. A well-executed architectural photograph will look good in a photographer's portfolio. Historical societies use photographs of sites for preservation purposes. Architectural photographs may be used in public exhibitions, trade shows, or to decorate a company's offices.

Photo 4.3 *With a 4 × 5 view camera the photographer has full control over the rendition of perspective. (Courtesy of John J. Kommelter.)*

TOOLS

Architecture is one of the principal domains of the large-format view camera. With it the photographer has full control over the rendition of perspective and the area of sharp focus in a photograph. The 4 × 5 camera is the most popular. Because of expense and size, the 8 × 10 and 5 × 7 have become obsolete. Use a 35mm camera for all assignments in conjunction with the 4 × 5 because almost every architect uses slides, and many journals use 35mm transparencies for reproductions. Because of the limited range of movement of the PC 35mm and 120 format lenses, the small-format camera is of limited use other than for documentary-type coverage of the architectural site.

A good selection of lenses should be available because the photographer may not be able to select the ideal spot from which to photograph. A wide-angle or telephoto shot may provide the coverage needed to illustrate a building. It also allows

Photo 4.4 *A wide-angle lens was used to photograph snack bar decoration. (Courtesy of Oak Ridge National Laboratories.)*

for the proper rendition of perspective in a photograph. For example, a wide-angle lens may be used to create a sense of spaciousness and expanded perspective, while a telephoto lens may compress the apparent distance between two buildings in a photograph.

Filters should be available so that the photographer has proper control over the tonal rendition of a scene if photographing in black and white, or with proper color balance if photographing in color. Polarizing filters are important in eliminating glare and saturating colors and to improve sky contrast in a photograph.

TECHNIQUES

In direct outdoor photography there are a few specialized techniques to mention. The polarizer filter is probably the most helpful device and the least used among beginning photographers. As mentioned earlier, the polarizer will darken the blue sky, thus making the white clouds stand out dramatically. Glare is removed from the roofing, highly polished floors, doors, windows, and furniture in interiors. It removes reflections and saturates the colors as well. Try taking comparison photos to see the difference.

Photo 4.5

Photo 4.6

Photographic comparison of an architectural study, without (4.5) and with (4.6) a polarizer lens.

Various filters and their effects are listed in Table 4.1. In black-and-white photography, a red filter will darken the sky almost to black, while a yellow filter will darken to varying degrees depending on the density of the filter. A red filter also reduces the effect of haze. A blue filter will increase and emphasize aerial haze.

TABLE 4.1 FILTER SELECTION

FILTER	LIGHTENS:	DARKENS:	FILTER FACTOR
Red (23A)	Light red	Light blue and green	6
Red (25A)	Medium red	Medium blue and green	8
Red (29F)	Dark red	Dark blue and green	16
Blue (47)	Blue	Yellow and red	6
Green (58B)	Green	Red	6
Yellow-green (13)	Dark yellow-green	Dark red-blue	5
Yellow-green (11)	Medium yellow-green	Medium red-blue	4
Yellow (6)	Light yellow	Light blue	1.5
Yellow (8)	Medium yellow	Medium blue	2
Yellow (9)	Dark yellow	Dark blue	2
Orange (15)	Medium red-yellow	Medium blue-green	2.5

Photo 4.7 *The building should be depicted so that the viewer experiences the volume and materials.*

The rule in using filters is that filters lighten their own color while they darken their complement. Thus a yellow filter lightens yellow while it darkens blue.

Composition plays a large role in whether an architectural photograph is eyecatching. Always examine a building from various angles before setting up to shoot. Walk around, looking from low and high angles, trying to visualize how the scene will appear in a finished photograph. The visual qualities are very different from what will be photographed. The first thing to look for is a distinguishing feature of the building. The photographer should be able to interpret a complex scene of architectural form, space, and material. The building should be depicted so that the viewer experiences its volume and materials.

There are many ways to view a building. Break the standard rules of composition, if necessary, to make each photograph a strong graphic as well as an architectural statement. A scale, such as people, can be added to a photograph. However, be sure that the scale is not dominant or too close to the camera, causing distortion. Photograph the scene in both vertical and horizontal compositions. The client or editor will often appreciate the opportunity to choose from among various selections. Experiment with various focal lengths; each provides a different effect. Try for a

Photo 4.8 *The structure and design is enhanced by the strong framing and depth is achieved with a fore-, middle, and background.*

revealing point of view that clearly defines and conveys the essential structural and design elements. This is the essence of architectural photography.

Lighting is also a very important aspect to consider. Almost anyone can focus a camera, but the right balance of lighting for a particular photograph is found through experimentation and observation. The lighting on a building is rapidly changing throughout the day. A photographer must be observant to these sometimes subtle changes. When walking around, one should be studying the lighting as it exists and visualize how the scene will look with a different type or direction of light. The photographer may have to return when the light is more favorable. The lighting should reproduce, even reinforce, the architect's intention. The orientation, time of

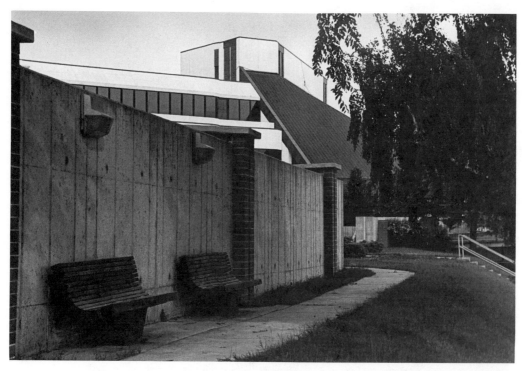

Photo 4.9 *The variations of light and shadow provide separation of planes in this photograph.*

day, siting, and mood of the natural lighting are all factors in the architectural photographic study. Even the weather may make a difference in a building's character. Always check the weather report, especially if you have to travel a fair distance.

The interplay of light and shadow may be the deciding factor in determining the character of a building. The light's nature and direction are factors in this interplay. For normal reproduction, light from a slightly overcast sky is preferable because its diffused light reduces contrast in the material's texture so that it can be recorded in detail on the film. If the architecture has strong lines, direct sunlight may be used for its contrasty, graphic effect. Cloudy weather provides the worst kind of lighting. This is because it has too little contrast to give adequate depth to the photograph.

It is sometimes advisable to use what may be called special effects to dramatize architecture. The use of black-and-white infrared film causes a building to stand out against a black sky and white foliage. In color infrared, the false color rendition produces a surrealistic effect. Experiment with this effect by using different filtration. Moonlight effects can be duplicated in broad daylight with deep red filters in combi-

Photo 4.10 *Strong sunlight may be used for its contrasty, graphic effects.*

nation with polarizing filters. The use of strong filters, unusual angles of view, tight cropping, posterization, and dramatic weather moods are only a few of the possibilities of special effects. However, some photographers have gone too far in their creativity and have attempted to make a sterile building more interesting through optical tricks and creative manipulation. Do not overdo it.

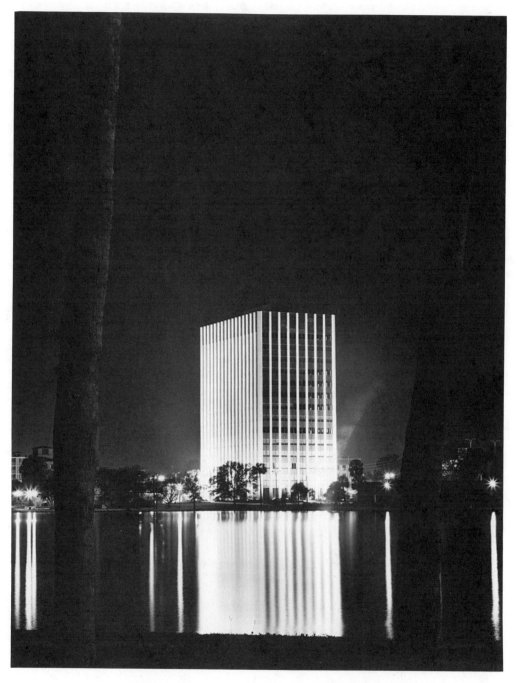

Photo 4.11 Hotel on Lake Eola, Orlando, Florida.

NIGHT EXTERIORS

Photographing industrial architecture during the daytime may present problems in trying to hide scars and unappealing areas. Fortunately, nature provides at dusk some of the most appealing light in which to photograph, and human beings have invented artificial lighting to enhance architecture at night. By combining the two, a very acceptable photograph can be made. This is often an eyecatching image for use on a wall or in an annual report.

Tools

Since night photography calls for multiple exposure, a camera capable of this is required. The film plane must not move between exposures. A 35mm camera in which the film must be rewound is not acceptable. A view camera is an ideal choice due to its large film size and ease of operation. Also needed is a steady tripod, one sufficiently sturdy to allow use of a large-format camera without shaking. The camera movements must be securely locked down, and an accurate meter is necessary. Since the exposures will be made under varying light sources, the meter should be checked in advance to be sure that it will read these different types accurately.

The film you choose is a matter of individual preference. Type L is recommended since it is balanced for tungsten lighting. The sky will be a very deep blue with tungsten, whereas with daylight-type film, the sky will be normal and the lights more yellow. It is recommended that a color negative material be used because the printer can correct any minor shift in the color due to reciprocity failure with long

Photo 4.12 Combining the lights of a plant with the light of dusk produces a pleasing effect.

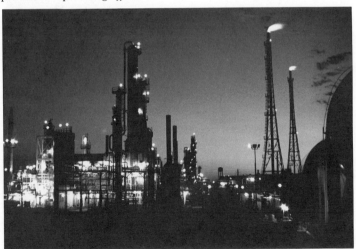

exposures. When photographing mercury vapor lights, use daylight type; under tungsten lights, use tungsten-balanced film; with sodium vapor lights, neither film will color-correct adequately.

Techniques

If possible, the weather should be clear. The best image will be where the building is silhouetted against a clear sky. However, an interesting photograph can be made by using reflections of the building in a wet parking lot, street, or a body of water. In dry weather a firehose can be used to wet down the street. Another technique of providing reflections is by using a front surface mirror directly below the lens. Angle it to provide a reflection that meets at the base of the subject. Hold it in place with clamps on a light stand.

One technique to try is making a single exposure taken right at dusk. Take a meter reading of the lights. When the sky is one f-stop under that of the lights in the building, make an exposure using the correct exposure for the lights. Bracket one f-stop over and one f-stop under the meter reading. Repeat this when the sky is two and three f-stops under the lights in the building.

Film loses sensitivity (reciprocity failure) during very long exposures. This loss must be compensated by providing more exposure than the stated meter reading. Check the data sheets that come with the film for proper recommendations concerning increased times and filtration to compensate for color shift.

The double-exposure method, which is the most widely used, calls for an exposure of the building in silhouette and an exposure after dark for the lights. Once

Photo 4.13 *Sunsets can provide striking silhouettes of industrial plants.*

a view is found, and the camera is set up, lock everything down. Set the aperture, which will not be reset for the second exposure. Pull the dark slide and allow the camera to sit for at least 2 minutes, to settle all vibrations, and to allow the film to settle in the holder. However, it is best to tape the film in the holder. Wait until the afterglow is in the sky. When the sky reads 25 footcandles on an incident meter, make the first exposure at one-fourth that time. For example, 25 footcandles might read 1 second at f-16. Make the first exposure at $\frac{1}{4}$ second at f-16. Cap the lens carefully. Do not touch the aperture, film holder, or camera. Do not even put the dark slide back in. In this situation, put the shutter on time or on the bulb setting and use a locking cable release. Leave the lens open until after the second exposure. Cover the lens with a cap or cover the camera with a dark cloth, being careful not to bump the camera.

Wait until it is pitch black in the sky, about 1 to 2 hours after dusk. Make the second exposure based on the lights in the scene. A good spot meter will help in this determination. One recommendation to try is $2\frac{1}{2}$ minutes for the average scene at f-16. Double this for weak lights, and cut it to one-third if the lights are unusually bright. Other methods, such as open flash, could be used to illuminate the building

Photo 4.14 *The Environmental Science Division greenhouses for air pollution research were photographed using the double-exposure method. (Courtesy of Oak Ridge National Laboratories.)*

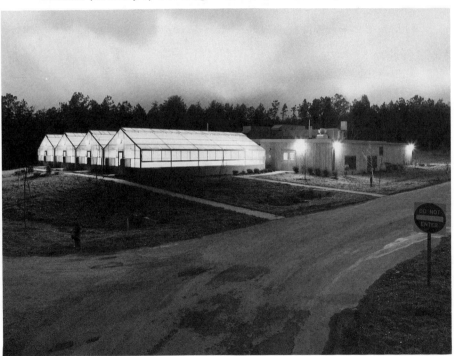

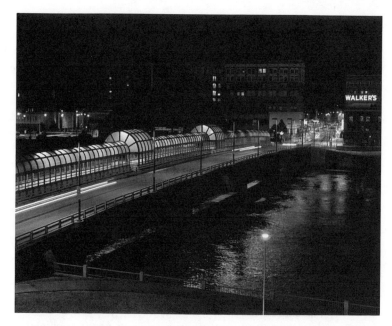

Photo 4.15 *After-dark photography of city lights is attractive.*
(Courtesy of Crayola England.)

Photo 4.16 Unusual angles can
be used to illustrate the lines of
architecture.

exterior. One method is to open-flash the walls while walking around. The automatic flashes on the market automatically squelch light to prevent overexposure. Another technique is to make several exposures, one for the skyline, one for interior lights through the windows, one for neon signs, and several flashes for the exterior walls. This takes considerable time and requires that there be a technician inside to cut the lights at the appropriate time. A two-way radio provides communication.

In setting up a composition, leave an unlit silhouette-like foreground to provide a feeling of depth. With the single-exposure method, it is also suggested to under-expose by one stop to retain the feeling of night photography. However, if at all possible, bracket your shots and choose the best.

SUMMARY

The successful photographer of architecture should ask:

Where are the photos to be used?
When are they needed?
Is color required?
What size reproductions are needed?
What are the essential features to show?
When is the light most favorable?
What has to be changed or readjusted for the perfect shot?
When can the property be readied for the photographer?

In other words, formulate a plan, scout the area, develop a shooting plan, then carry it out.

The composition of the photograph and illustration of the graphic design elements, as well as the control and understanding of light, is what architectural photography is all about. Proper balance of these elements is what the photographer should strive for.

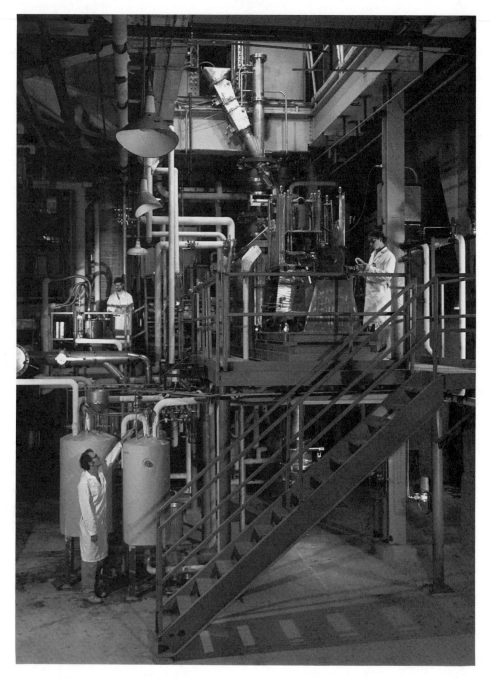

Photo 5.1 Nuclear fuel recycle research facility. (Courtesy of Oak Ridge National Laboratories.)

Chapter 5

Plant Interiors

OBJECTIVES

Upon completion of this chapter, you should be able to:

- List the various uses for photographs of plant interiors.
- Explain various aspects to look for when photographing an interior.
- List the three types of lighting found in plants and their important aspects in relation to photography.
- Explain color light-balancing filters and when to use them.

INTRODUCTION

Many of the techniques and discussions that follow concerning photographing industrial plant interiors are applicable to the photographing of any interior, including residential and public buildings. Regardless of the type of interior, the photographer must first decide what is important in the interior, what the important features or elements are, and how they are to be depicted. These decisions will determine camera position, angle of view, and the type of lighting needed. Also determine what the photograph is of, who it is for, and how it will be used.

Photo 5.2 *Space designers use photography for planning interiors.*

USES

There are many potential clients for interior photography. They include architects, cabinetmakers, space programmers, remodelers, general contractors, interior designers, interior decorators, drapery firms, realtors, manufacturers and distributors of home furnishings, and those actually occupying the space, such as managements of hotels, hospitals, corporate offices, and various publications.

The uses for interior photography are growing every day. Advertising services producing posters, brochures, transparency displays, sales presentation materials, annual reports, menus, photomurals, and enlargements for trade fairs and exhibitions are just a few examples of interior photography.

TOOLS

Detail is all important, as is correct perspective. A view camera is necessary to correct the perspective and to use its ability to use tilts and swings to gain maximum sharpness (Scheimpflug rule). One problem that you may encounter is moving people or machinery. If stopping motion is important, flash may be used. On extremely long exposures, moving people will not be recorded. The moving machinery will blur into a mass of white similar to moving water in scenics. Therefore, if flash is not used and motion needs to be stopped, a fast film should be used.

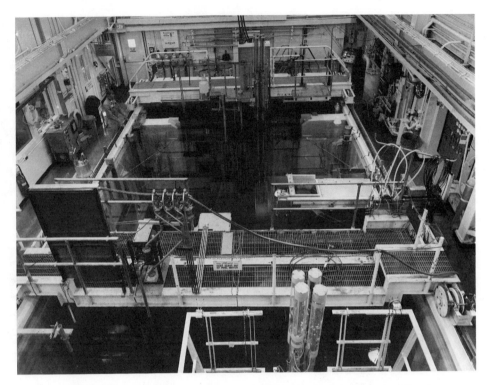

Photo 5.3 *A closed-in appearance results by showing three walls of an interior. (Courtesy of Oak Ridge National Laboratories.)*

TECHNIQUES

Finding the right viewpoint or composition requires careful observation. Walk around, crouch, and stretch, always looking for the definitive angle. Note how objects and the furniture cut into each other. Move them if necessary to establish a pleasing rhythm. Establish lead-in lines by using furniture arms, for example, on the edge of the photograph. Photographically pleasing elements are determined by proportion, volume, color, texture, and lighting. By showing three walls of one room, a closed-in appearance and a reduction of visual scale results. Angled compositions seem to open the room up and give a feeling of spaciousness. Usually, a horizon line a little higher than the viewing level of a seated adult should be correct for the residential interior.

Interiors should be lighted to allow for depth by keeping the back walls lighter than the foreground and having the main light angled 60 degrees or more into the scene. The eye is thus led into the composition and an illusion of depth is achieved.

Photo 5.4 *A high point of view will show the interior of a plant to its best advantage. (Courtesy of Oak Ridge National Laboratories.)*

When photographing the interior of a plant, one is usually concerned with showing it to its best advantage; thus a higher-than-eye-level view is recommended. This may be achieved by using a forklift, scaffold, ladder, or overhead crane. The foreground and background should be well lit and sharp. This will require a small f-stop and use of supplementary lighting to fill the shadows, although in many well-lit shop areas, this will not be necessary.

In industrial interiors there are many problems to overcome. The machinery used in heavy industry may cause a building to vibrate to such an extent that a tripod will "walk" across the floor. To subdue such vibrations, place foam rubber pads about 2 to 3 inches thick under each tripod leg to help absorb the vibration. Try not to interrupt the work that is going on, as this costs the company money. Schedule the photography during breaks, such as lunch or routine maintenance breaks.

When scouting the location before setting up the photographic equipment, check the power supply. The electrical plugs may be some distance from where they will be needed, necessitating bringing in enough cables to cover the distance. The plug type may be of a different sort than the standard grounded parallel blade normally used, and will require special adapters or direct connection to the power

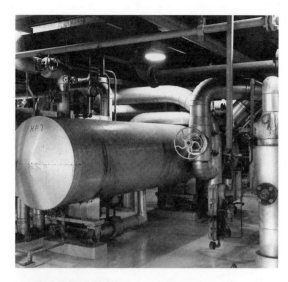

Photo 5.5 *Heavy machinery in operation may cause the camera to vibrate. Be sure to use cushion pads. (Courtesy of Jerry Seal.)*

Photo 5.6 *Most well-lit shop areas will need only a small amount of fill light. (Courtesy of Crayola England.)*

box. In some areas there may be no electrical supply, requiring the use of portable, battery-operated flash or even the use of flashbulbs.

Several other factors also need to be checked. How large are the rooms? This will determine what lenses will need to be taken and how much total work area there

is. Of what type is the existing light? This will determine whether to photograph with available light, mixed lighting, or total lighting control.

There are basically three types of lighting in industrial interiors: (1) available light, (2) flash and/or tungsten fill, and (3) fluorescent and mixed lighting.

Available Light

It is fortunate if there is enough available light present to make the exposure. The most common problem encountered is a brightness range that makes it impossible for the film to record detail in both shadows and highlights. In black-and-white photography the contrast range can be manipulated using the "zone system." In this way the photographer can increase or compress contrast by varying the exposure and development (see Table 6.1).

The zone system cannot be used with color material because of color crossover when altering development. However, the main problem in color photography is one of color light balance. For example, with window light, a cloudless blue sky

Photo 5.7 *The potassium topping cycle test facility was photographed utilizing the "zone system" to control contrast. (Courtesy of Oak Ridge National Laboratories.)*

will produce a blue cast in the shadow areas of machinery. Only under an overcast sky should available light be used with color; otherwise, a fill light will need to be used.

Flash and Tungsten Fill

The general practice is to use a flash or to place tungsten fill in the scene to lighten the shadow areas. The photographer should deliver an image to the client that closely resembles the interior as it appears to the human eye. In general, the best way to light is to use what is already there, if possible. The character of the room has already been established by the interior designer.

All that is needed is to get a recordable light level, a pleasing ratio, and to balance the color of the sources to achieve a photograph that looks right. Determine the direction from which the prevailing light source is coming, and place the lights within the areas that are available to complement and supplement the daylight. Electronic flash eliminates the balance problem, with daylight entering the windows

Photo 5.8 *This photograph was exposed utilizing only the available tungsten light. (Courtesy of Oak Ridge National Laboratories.)*

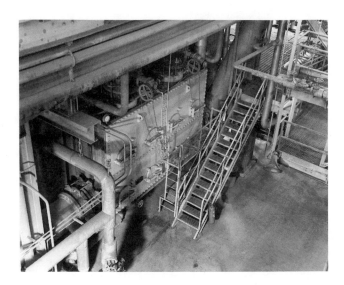

Photo 5.9 *This photograph was lit using available light with a tungsten fill. (Courtesy of Jerry Seal.)*

if daylight-balanced film is being used. If tungsten lights are used to fill, balance this for daylight by using a conversion filter over the light source. A blue filter converts it to daylight with a considerable loss of intensity. There are available blue photofloods and blue flashbulbs (by special order) for use as a fill and to replace regular tungsten household bulbs in lighting fixtures.

The use of umbrellas is valuable for producing broad, indirect sources to add as fill. With bounce lighting there will be no ambiguous or multiple shadows. Add light to separate tones and lift shadows. Be careful not to have too many shadows going in too many directions. Evaluate where and why lighting is needed to supplement existing lighting. Try to achieve lighting that borders on ambient quality, to illuminate a room or a fixture without overpowering the area or object.

One technique to try is using a blue bulb to paint the interior. With ASA 100 film and an average-size residential room, paint the interior with a 650-W blue bulb for 4 seconds. Allow another 4 seconds' exposure for the daylight entering the window. The aperture should be placed at f-16. If there is less daylight, use 6 seconds for the daylight exposure.

Fluorescent and Mixed Lighting

One of the biggest problems facing the photographer is balancing the lighting in a plant. There are many sources, each of which requires a different degree of filtration (see Table 5.1). The best way to determine the correct filtration is to use a tricolor meter which measures the red/blue and red/green ratios of the light source. A regular color temperature meter measures only the red/blue ratio and is not adequate for fluorescent sources. The color temperature meter measures sources that are black-body radiators and have a true Kelvin rating. Fluorescents are discontinuous sources.

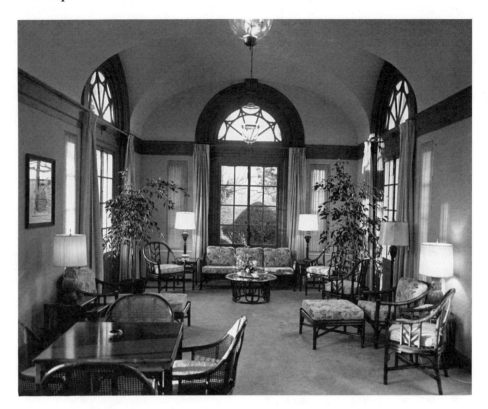

Photo 5.10 *Example of a mixture of daylight and painting with a blue bulb.*

TABLE 5.1 FILTER/FILM RECOMMENDATIONS

LIGHT	DAYLIGHT FILM	TUNGSTEN FILM
Sodium (Lucalox)	SinghRay Lucalox	50M + 20C SR-L15 or FLB
Metal halide	30M + 10Y	
Mercury	Not recommended 50R + 30M + 30Y SRD	Not recommended SRB
Average fluorescent, cool white	30–40M FLD or SRD	50M + 60Y FLB or SRB
Daylight	None	80A
Tungsten	85	None

Instead of the filament being heated as in the tungsten light, a fluorescent light is produced by a stream of electrons traveling from one end of the lamp to the other and exciting the phosphor on the inside wall of the glass tube. They do not have a continuous spectral energy curve, thus the need for the tricolor meter. Another type of light found in increasing numbers in industry is the high-intensity discharge lamp. This produces light by passing a short electric arc through a chemical atmosphere. There are three basic lamps of this sort: high-pressure sodium, metal halide, and mercury lamps.

Filters for correction come from many manufacturers, usually designated FLD, or FLW to correct average "cool white" fluorescents to daylight film. The FLB corrects fluorescents to tungsten balanced film. These are average filters and are to be used if a meter is not available for exact measurements. The SinghRay filters, developed by Dr. Robert Singh, respond to the actual fluorescent light and are rated SRD and SRB for daylight and tungsten film, respectively. The SR-L15, made for high-pressure sodium lights, works extremely well. Mixing the light sources requires that you filter the film, the lights, or both to balance the photograph properly. If daylight film is used under tungsten, an 80A filter on the lens will balance the scene. If tungsten film is used under daylight, an 85 filter will balance it. It is the mixed-light areas that make the task difficult. The common case is the use of daylight film under fluorescents. To correct, a 30–40M filter is needed. An electronic flash is

Photo 5.11 *Mixed lighting presents difficulties for the photographer. Daylight, fluorescent, and flash were balanced to produce this photograph. (Courtesy of Oak Ridge National Laboratories.)*

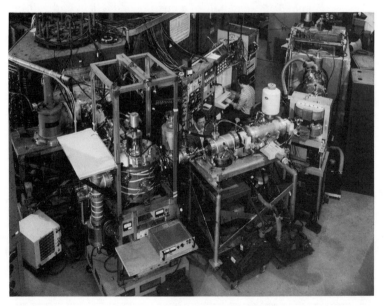

balanced for daylight. It must be corrected for fluorescent light since the film was corrected to that light source. The complementary filter must be placed over the flash, in this case a 30–40G. A tough green plastic gel available in sheets or rolls can be placed over the light source. A flash meter will be needed to determine the distance the fill flash is to be placed from the subject, since the exposure is based on the main light in the room. If a tungsten-based film is used, an amber-colored gel will balance the fill flash. There is not much that will balance mercury lights. This is where the photographer needs to carry a lot of lights, to light the area independently. The filters suggested should achieve a close-enough balance to enable printing.

SUMMARY

The photographer working in plant conditions is faced with many challenges. The physical conditions are often an obstacle to excellence. Dirt, vibrations, electrical supply, and type of lighting are all factors to be considered. The activity taking place can affect the photograph pictorially, and the photographer must possess a keen eye to meet these challenges.

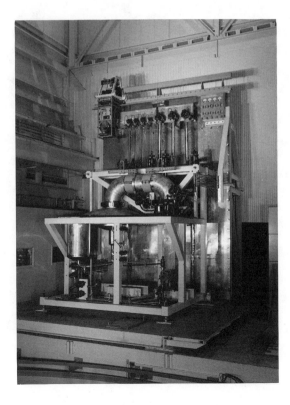

Photo 5.12 Some areas will need to be totally lit by the photographer. When faced with multiple lighting, watch out for multiple shadows. (Courtesy of Oak Ridge National Laboratories.)

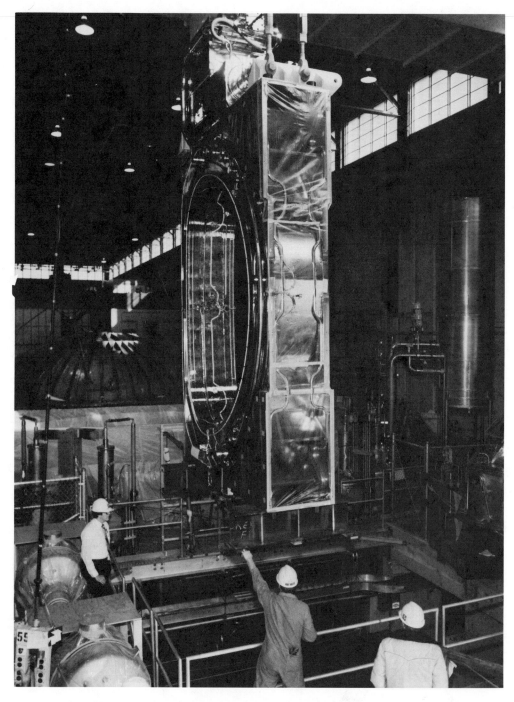

Photo 6.1 Superconducting magnet for fusion research. (Courtesy of Oak Ridge National Laboratories.)

Chapter 6

Production Floor

OBJECTIVES

Upon completion of this chapter, you should be able to:

- Explain why machines are photographed.
- Explain what to look for in composition when photographing machines.
- List various lighting approaches based on surface characteristics.
- Explain reflection control.
- Explain three-point lighting.
- Explain painting with light.
- Explain using the GAD formula with flash fill.
- Explain contrast control.

INTRODUCTION

One of the most difficult assignments for the industrial photographer is photographing on the production floor. This is because motion must be stopped in the photograph and any halt in production costs a company money. The photographer must know from the beginning whether an objective record is to be made or a more refined photograph is needed. When photographing machinery, the aim is usually to bring out the functional design of the machine, clearly revealing its controls and functions.

Photo 6.2 When photographing machinery, the aim is to bring out the functional design of the machine. (Courtesy of John J. Kommelter.)

TOOLS

A view camera is suggested to provide proper perspective control of the lines of the machine. The choice of lens will supply the required perspective. Where space is at a premium, a wide-angle lens, coupled with the shifts of a view camera to photograph around obstacles, may be required. A front surface mirror may be used to photograph a confined space by placing it at a right angle to the camera. The type of job will dictate the technique and equipment to be employed.

TECHNIQUES

Look for the side of the machine that shows the controls clearly. The choice of camera viewpoint is dictated by the function of the machine. However, it is preferable to photograph it obliquely to show the front and one side. If necessary, clean

60

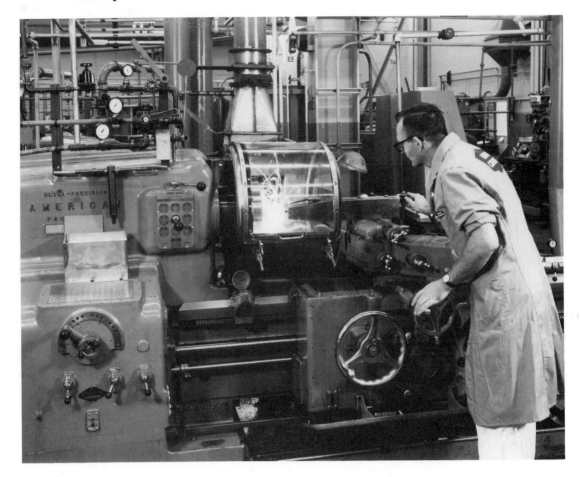

Photo 6.3 *The choice of camera viewpoint is dictated by the function of the machine. (Courtesy of Oak Ridge National Laboratories.)*

the floor and the machine of grease and dirt. All of the control labels should be readable. Above all, the entire machine must be in focus. If the depth of field is controlled properly, the background may go soft, thus focusing attention on the machine.

The photographer should examine a complicated machine and choose lighting that brings out every detail, reveals the construction, and gives a three-dimensional emphasis to the most important elements. In today's well-lit shops, lighting may be needed only to fill the shadows. Since shadow detail is a requirement, some type of fill is usually necessary. Available light may be used for the main light, with a soft floodlight used for fill. Mirrors might also be used to place fill light in recessed areas.

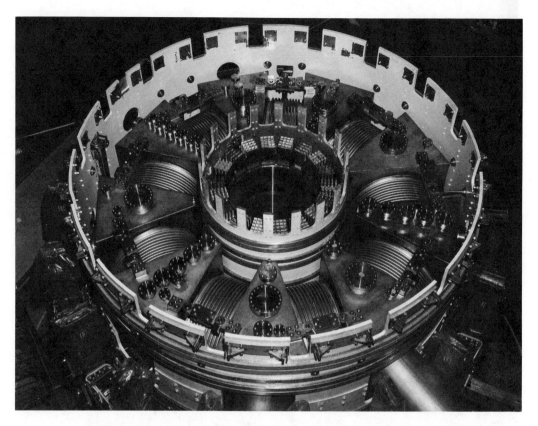

Photo 6.4 *Available light and flash fill was used to record this image of a fusion research and development machine. (Courtesy of Oak Ridge National Laboratories.)*

Diagram 6.1 *Angle of incidence law: the angle of incidence equals the angle of reflection. This law, if not observed, will result in light entering the lens. To correct, move the light or the camera, or both, to eliminate the reflection.*

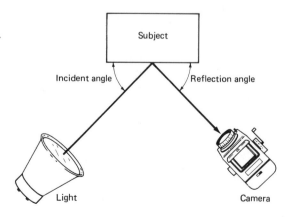

Eliminate unwanted lighting entering doors and windows by closing them, by waiting until night, or by using gobos, which are flags that go between the light and the object. Eliminate reflections from machines by using dulling spray. Painting the machine can be helpful in photographic reproduction. Glare can be avoided by skillful placement of the lights. When photographing machinery, always keep in mind that *the angle of incidence equals the angle of reflection.*

Machine surfaces will make a difference in the lighting approach of the photographer. For example, if a rough metal surface is lighted by a contrasty light, it will appear brighter than a polished surface under the same lighting. With some highly reflective machines or metals, it is the reflection that is recorded. By setting up large matte reflectors, lighting them, and adjusting them so that they are being reflected in the metal, the result is a smooth reflection in the photograph with the required brightness. By applying strips of black paper to the reflecting material, the even appearance is broken up so that it does not look perfectly smooth.

Photo 6.5 *With highly reflective surfaces, the angle of incidence law is important. (Courtesy of Oak Ridge National Laboratories.)*

Some reflections may be controlled by placing a polarizing filter over the camera lens. This does not work with metallic reflections. With these, some control is gained by polarizing the light source and cross-polarizing with a filter on the camera. Even with this method, it is not possible to eliminate all reflections.

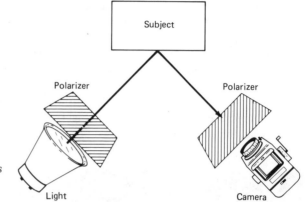

Diagram 6.2 *Cross polarization will eliminate most glare from nonmetallic surfaces and from some metals. Place a filter oriented vertically over the lights and another oriented at 90 degrees over the lens for maximum control.*

Diagram 6.3 *With the three-point lighting method, the camera can be placed anywhere on the circumference and the photograph will have a main, a fill, and a back light.*

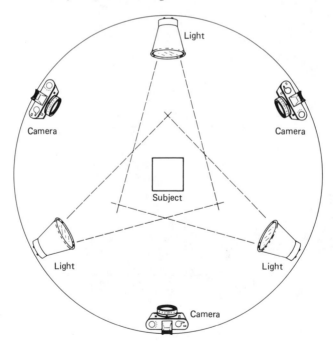

Three-Point Lighting

One method of arranging your lights on a rapidly changing production floor is to use a three-point lighting method. Three lights are placed high in an equilateral triangle, pointing toward the subject. The camera can be placed anywhere on the circumference of this circle and will have a main, a fill, and a back light. The intensity can be varied if necessary by changing the power settings. Each light can be slaved by a wink light on the camera, thus relieving the photographer from running wires that may be in the way.

Painting with Light

Painting with light is an old technique that should be used more than it is. It involves painting the machine with a moving light. This technique gives even, shadowless lighting. Blemishes and slight unevenness of metal surfaces are suppressed with this

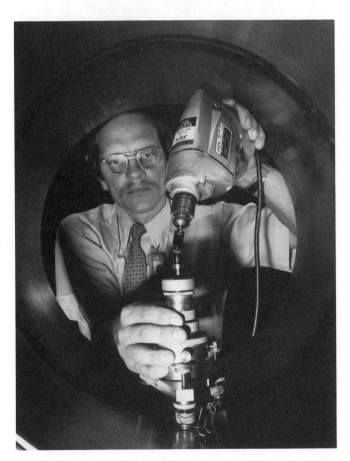

Photo 6.6 *Example of three-point lighting. (Courtesy of Oak Ridge National Laboratories.)*

Photo 6.7 *Painting with light gives smooth, even lighting.*

method. Painting is best done when there is low ambient light. Once the camera is set up, the light is placed at camera position and metered using a reflected reading. Stop down as much as possible, which will allow a longer exposure time in which to work. This allows for a smooth painting. Do not forget to figure for reciprocity. Wave the light in a figure-eight fashion on each side of the camera. Total exposure is about five times that of the meter reading. An instant print test will give you a good idea where you need more or less light and is a good guide to the proper exposure. As long as the light is kept moving and is not directed toward the lens, very uniform lighting will result. Painting with light can be combined with available

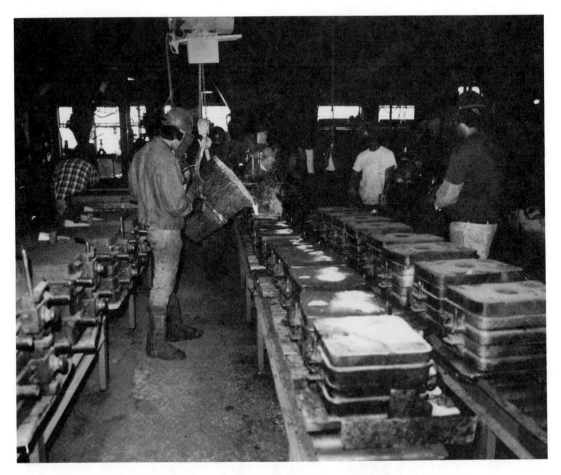

Photo 6.8 *Flash fill combined with ambient light.*

light. It is best to make one exposure for the room lights, turn them off, and then make a second exposure for the painting.

Fill Flash

When using flash for a fill, the problem is to balance the ambient light with the shutter speed, and then adjust the exposure of the flash with the aperture. Select an f-stop to photograph with, make a meter reading, and set the shutter speed accordingly. If a focal plane shutter is used, trouble may result with the lens synchronizing at only one speed. Check the guide number of the flash. Use the GAD formula to

adjust the distance. Suppose that a reading is made and f-16 is the needed aperture. Meter the scene and set the shutter speed accordingly. Assume the flash has a guide number of 110. You wish to use f-16, which means that to fill the machine with a one-stop ratio, the light should be at f-11. Thus, using the formula

$$GN = A \times D$$

$$110 = 11 \times D$$

$$D = \frac{110}{11}$$

$$= 10 \text{ feet}$$

where GN is the guide number, A the aperture, and D the distance, we find that the fill flash must be set at 10 feet.

Photo 6.9 *Umbrellas provide a soft fill for production floor portraits. (Courtesy of Oak Ridge National Laboratories.)*

Umbrellas

Umbrellas can be used to provide a soft fill lighting. When using umbrellas, the aim is to achieve a uniform, shadowless illumination. Next to painting, this is perhaps the softest of the fill methods. A 36-inch umbrella can be used on location for large areas and an 18-inch umbrella for small-object jobs. Several varieties of material are used in the construction of umbrellas, and each has a different effect on the results. Experiment with the surfaces to determine which is preferred.

Contrast Control

Contrast can be a problem when photographing highly reflective machines or, in some cases, drab ones. Here is one lighting trick to give softer negatives: Use contrasty lighting while providing a correspondingly more intense electronic flash exposure from the camera direction as a *light spray*. The short flash duration considerably flattens the gradation without detracting from the brilliance.

Another way to adjust the contrast range of the scene is by altering the exposure and development of the film. Measure the highlight and shadows of the subject. A seven-stop difference is considered to be normal. If it is less, underexpose and overdevelop. If it is more, overexpose and underdevelop (see Table 6.1).

TABLE 6.1 CONTRAST RANGE ADJUSTMENTS

BRIGHTNESS RANGE (NUMBER OF STOPS)	EXPOSURE	STOPS	DEVELOPMENT
1, 2, or 3	$\frac{1}{3}\times$	Under $1\frac{1}{2}$	$2\times$ or 100% more
4	$\frac{1}{3}\times$	Under $1\frac{1}{2}$	$1.5\times$ or 50% more
5 or 6	$\frac{1}{2}\times$	Under 1	$1.2\times$ or 20% more
7	Normal	Normal	Normal
8	$2\times$	Over 1	$0.8\times$ or 20% less
9	$4\times$	Over 2	$0.7\times$ or 30% less
10	$6\times$	Over $2\frac{1}{2}$	$0.6\times$ or 40% less

The recognized means of eliminating distracting backgrounds are: photographing by night, masking out in enlarging, burning in the background during enlarging, and airbrushing. Backgrounds can be toned down by leaving them in darkness or by lighting the machine so that the background has less exposure. Masking methods are covered in Chapter 12. In any case, the background should not be distracting or compete with the machine for attention.

Photo 6.10 Contrast control needs to be employed in situations where the brightness range exceeds the capacity of the film to record it. (Courtesy of Oak Ridge National Laboratories.)

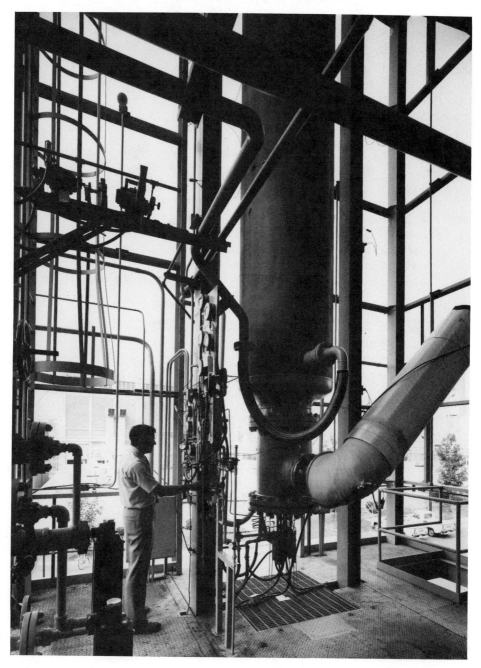

SUMMARY

Photographing machines is difficult when all the components, metal types, and environmental conditions are considered. Lighting is of paramount importance, and various methods, such as three-point lighting, fill flash, contrast control, and painting with light, may be used to effectively light machines.

Photo 6.11 *Distracting backgrounds can be toned down by "burning in" in the darkroom. (Courtesy of Oak Ridge National Laboratories.)*

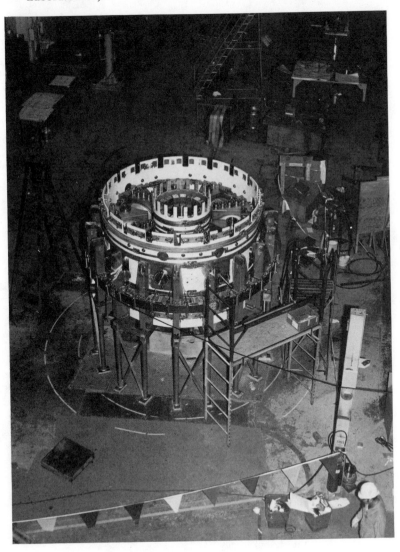

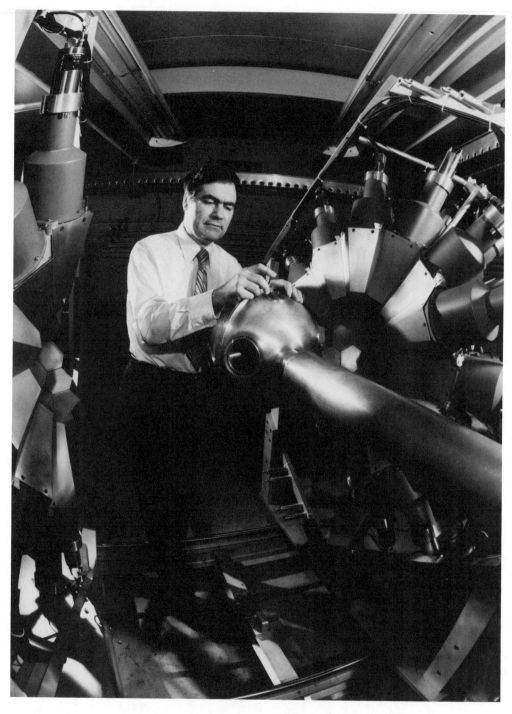

Photo 7.1 Crystal ball spin spectrometer. (Courtesy of Oak Ridge National Laboratories.)

Chapter 7

Location Portraiture

OBJECTIVES

Upon completion of this chapter, you should be able to:

- Explain why portraits are needed in industry.
- Explain how to deal with executives.
- Choose the proper equipment for location portraiture.
- Be able to analyze the subject and take corrective action.

INTRODUCTION

One very important aspect of photography in industry is the photography of people. This may be a worker at a machine or it may be the president of a company. Without people, industry would be a pile of lifeless machines and metal.

USES

There are many uses for portraits. They may be used for feature stories in trade publications, showing workers in their environment or executives in their offices. Other uses include news releases; permanent displays in offices, lobbies, or conference rooms; and for annual reports, technical exhibits, advertising, audiovisual productions, biographical packages, organizational references, magazines, or personal portraits.

Photo 7.2 *Scientist with molecular model. (Courtesy of Oak Ridge National Laboratories.)*

Most companies would not think of being without photographs of their products or services; neither should they neglect photographs of their most important asset—people. A good professional portrait should be presented to the news media for news stories, speaking engagements, awards, special honors, achievements, or promotions. There are many internal publications or *house organs* in which photographs can be used: for example, newsletters and field communications. Wall displays can create an attractive and informative photo grouping or serve as a focal point in home decor.

TOOLS

The equipment that is needed may vary depending on the photographer's individual style. When in a studio, a neutral, subtle, painted background is preferred. When on location, look for wood paneling, large doors in offices and boardrooms, and

Photo 7.3 *One background separation light made this location portrait of a quality control engineer a success. (Courtesy of Oak Ridge National Laboratories.)*

large leather chairs and desks to use as props. Tripods may be a problem in tight spaces. A clamp with protective pads that attaches to door frames or chairs may be necessary to hold the camera or reflectors and small strobes. A small attaché case will hold several small strobes, PC cords, and a couple of light meters.

Camera

Ideas about which camera format to use range from the 35mm to the 4 × 5. Each has its merits, and the choice depends on the photograph's final use. For editorial-type coverage a 35mm will allow for the most mobility in getting a candid, photo-journalistic look. The $2\frac{1}{4}$-inch format camera allows for mobility and the use of a larger negative size for enlargement. It is probably most favored by the professional portraitist. A 4 × 5 camera allows for image and perspective control, such as increasing depth of field and correcting certain distortions.

Photo 7.4 *A 4 × 5 view camera provides for a high-quality portrait. (Courtesy of Oak Ridge National Laboratories.)*

Lenses

The choice of lens is often dictated by the space available in which to shoot. Much of the distortion in many portraits is from choosing a wider-than-normal lens and then moving too close to the subject to fill the frame. It is advised that a longer-than-normal lens be used for portraits. It should be about twice the diagonal measure of the film size being used (see Table 7.1).

Although the old trick of a black stocking over the lens and Vaseline works well to diffuse an image, a lens designed for soft focus is better and provides more control. Remember that *soft focus* is not the same as *out of focus*. Diffusion at the camera is also different from diffusion at the enlarging easel. Try each effect to see the subtle differences.

TABLE 7.1 PORTRAIT LENS SELECTION

FILM SIZE	FOCAL LENGTH
35mm	75 mm
$2\frac{1}{4}$ square	120 mm
$2\frac{1}{4} \times 2\frac{3}{4}$	135 mm
4×5	8–10 in.
5×7	12–14 in.
8×10	14–16 in.

Photo 7.5 A lens with a slightly longer than normal focal length provides for distortion-free portraits. (Courtesy of Oak Ridge National Laboratories.)

TECHNIQUES

Executives consider the photographer to be the expert in photography, therefore to be professional. Do not waste their time by fiddling with the camera. This indicates a lack of knowledge of its operation and will result in a lack of confidence in the photographer's abilities on the part of executives. A pleasant conversation will relax both the photographer and the subject. Do not discuss business or try to promote yourself at this time. Listening with interest will relax the person. Have the executive talk or show a real activity. This will be more believable than trying to fake an action.

It is very important to present yourself as a professional. This includes having a neat haircut and wearing dress appropriate for the occasion. This may seem to be discrimination, but it is a fact that photographers are often judged by their clothing

Photo 7.6 Oak Ridge National Laboratories operations managers. (Courtesy of Oak Ridge National Laboratories.)

and the length of their hair rather than by their worth as a professional photographer.

Try to talk to the subject in advance of the session so that the purpose of the photograph is known. It is essential to establish rapport as soon as possible. If the photographer can have a few minutes to spend chatting before the sitting, he or she should feel extremely lucky. Never feel "in awe" of anyone. You are just as much a professional as the other person is. Never criticize, though. Try to be pleasant and compliment the subject as often as possible without being gushy.

In earlier days, if photographers could get an executive to pose for a photograph, the executive was generally shown with an image of respectability, conservatism, and stability. People wanted to be photographed as "captains" of industry, "defenders" of the faith, and "builders" of empires—to look like the mighty barons they considered themselves to be.

Photo 7.7 Working with award-winning scientists requires professionalism on the part of the photographer. (Courtesy of Oak Ridge National Laboratories.)

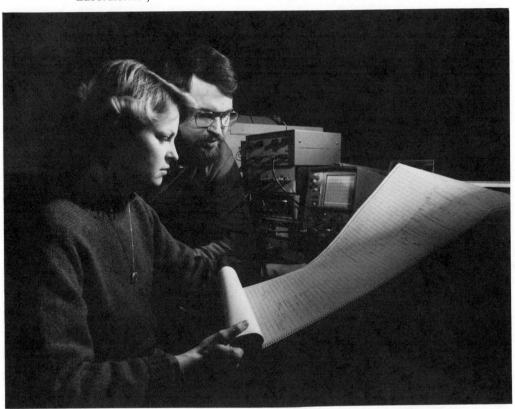

Photo 7.8 Executives, scientists, and engineers are no longer photographed in a studio. They may wish to be photographed with their projects. (Courtesy of Oak Ridge National Laboratories.)

Photo 7.9 A natural pose and expression are effects to strive for. (Courtesy of Oak Ridge National Laboratories.)

Today, corporations know the value of good public relations and community goodwill. Today's portraits give the viewer more than just a person; they also show the environment of the company. The modern style of executive portraiture is no longer simply the head and shoulders portrait; rather, portraits are informal, full length, and show the working environment. The posed portrait looks unnatural to today's sophisticated viewer. This means getting the executive involved and doing something instead of just looking in the camera with a blank look. The effect to strive for is a natural pose and the appearance that the subject is listening to an associate or getting ready to speak to him or her. For a simple news release a head shot is still used because it can be cropped as a vertical one-column reproduction.

Lighting

Lighting is the key to good portraits. Rarely is the available light ideal for all subjects or situations. Scout the area in advance to help determine what to bring. Make a lighting diagram showing the type and placement of existing lights. Remember not to *overlight*, as the multiple shadows will give away the fact that the photograph is not natural. Remember the rule *"one sun, one shadow."*

Photo 7.10 For drama and mood, creative lighting techniques should not be overlooked, as in this photograph of transuranium element research. (Courtesy of Oak Ridge National Laboratories.)

Umbrellas used as reflectors produce a soft broad coverage that is especially useful for older subjects. The trend away from the retouched portrait makes the umbrella an ideal light source, as it requires less retouching. Other material may be used to bounce light into. Remember that if the material has a color cast, the light that is bounced will take on that color. Use a warming filter to rid the subject of the bluish tint of the strobe.

Try using natural daylight and a reflector to fill the shadows. The north light that was used in the old days is still hard to beat for portraits.

Begin to analyze your subject as to age, body shape, and clothing style. This will provide ideas on how to approach the photographic session. In a formal style the poses should be more determined and deliberate. With men, try to lean the body into the camera. Be sure that the cuffs extend beyond the coat sleeve. Do not tilt a

Photo 7.11 *In working portraits, make sure that the proper safety equipment is utilized. (Courtesy of Oak Ridge National Laboratories.)*

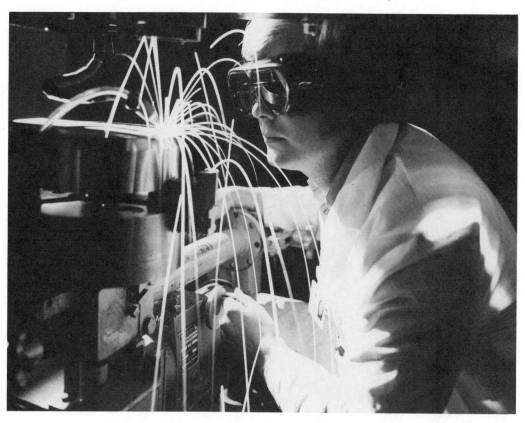

man's head, as this makes him look weak. With men, keep the hands apart, and introduce sharp angles at the wrist, elbows, and other joints. With women, use gentle angles for a more feminine look. Small props in the hands of men give them a natural look. Use a magazine, small book, glasses, or a pipe. Check the hair, the tie, and the collars and lapels. Make sure the coat is not bunched at the shoulders. Empty the pockets of bulging pens and wallets.

You must learn to look at the subject and analyze the facial characteristics to determine the best type of posing and lighting to correct defects. For example, if the subject's face is wider than normal, *short* lighting will slim it down. In Table 7.2 are listed the more common problems that will be encountered and some of the possible remedies.

Photo 7.12 *Portrait of a coal researcher. (Courtesy of Oak Ridge National Laboratories.)*

SUMMARY

Photographing people in industry is vital to the success of a company. Considering the many public relations uses, it is necessary for the industrial photographer to be able to photograph a subject's ''better side.'' Choosing the proper equipment should be secondary to selecting the proper lighting and style to enhance the subject.

TABLE 7.2 PORTRAIT PROBLEMS AND REMEDIES

Wide or prominent forehead or baldness	Tilt subject's chin upward
	Lower camera
	Use head screen (gobo)
	Use barn doors
	Feather light
	Avoid back or edge light on hair
Long nose	Tilt subject's chin up
	Face subject into lens
	Lower main light
	Lower camera
	Avoid profiles
Short nose	Raise main light
	Tilt subject's head down
	Use front lighting
Broad nose	Use short lighting
Angular nose	Have subject face camera
	Place main light to produce straight line
	Highlight subject's nose
Crooked nose	Avoid front view
Narrow chin	Tilt camera up
	Lower camera
	Use three-quarter head shot
	Raise subject's head
Double chin	Tilt subject's head up
	Lean subject forward
	Use high camera view
	Raise main light
Wide jaw	Use rim light
	Use short light
	Raise subject's head
Short neck	Lower camera
	Tilt subject's head up

TABLE 7.2 (*Cont.*)

Long neck	Raise camera
	Tilt subject's head down
	Lean subject forward
Broad round face	Use short light
	Use three-quarter head shot
Narrow face	Use broad light
	Subject should face camera
	Raise main light
	Use umbrella
	Shade subject's ear
Wrinkled face	Use soft light
	Feather light
	Subject should not smile
	Use diffusion
	Use butterfly light
	Lower main light
Facial defects	Put subject on shadow side
	Put subject away from lens
Big ears	Show only one ear
	Use head screen
Glasses	Tilt camera downward
	Raise or lower subject's head
	Raise lights
Eyes deep-set	Raise subject's head
	Lower main light
Pop-eyes	Lower camera
	Raise main light
Droopy eyelids	Subject should look up
Short, stout	Use standing pose
	Use props in front
	Low key
	Use small image in viewfinder
	Use vignettes
	Turn subject sideways
	Subject should wear dark clothes

Photo 8.1 Spin spectrometer. (Courtesy of Oak Ridge National Laboratories.)

Chapter 8

Product Assembly

OBJECTIVES

Upon completion of this chapter, you should be able to:

- List various uses for product assemblies.
- List aspects to consider when photographing assemblies.

INTRODUCTION

A series of photographs of the taking apart or the putting together of an object classifies them as assembly photographs. This could be anything from how to bake a cake to assembling the space shuttle.

USES

Product assemblies and disassemblies have many uses. The primary use is in the education and training of personnel. Photographic records become a valuable aid in this instruction. If you have ever tried to put together a bicycle with only written instructions translated from Japanese, you will relate easily to the use of photography in a manual.

Photography can illustrate how to do a job. At a lumber store recently, I saw a series of nine photographs illustrating how to erect a small utility shed. Each

photograph had a two- or three-sentence caption. With this one sheet of instructions, the construction could be done easily.

In safety training, photographs could show workers how to move, how to bend over, or how to pick up packages or materials so that they do not injure themselves.

In manuals it might be necessary to illustrate the sequence in which a particular

Photo 8.2

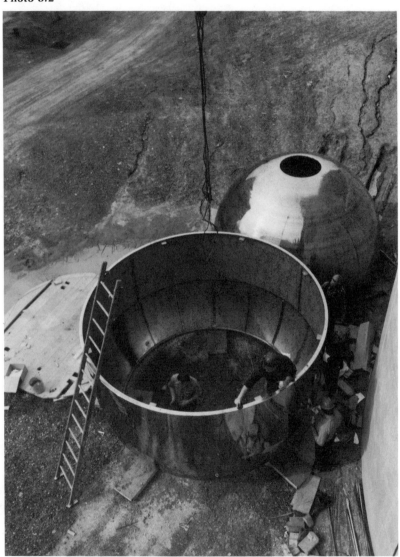

job is done: step A followed by step B, and so on. Some projects may require many steps. Within the manual an illustration of the parts that are needed and the tools required and any special techniques that are to be employed could be shown.

Photography plays a large role in providing information for technicians and mechanics. Repair manuals showing step-by-step instructions are in common use in

Photo 8.3

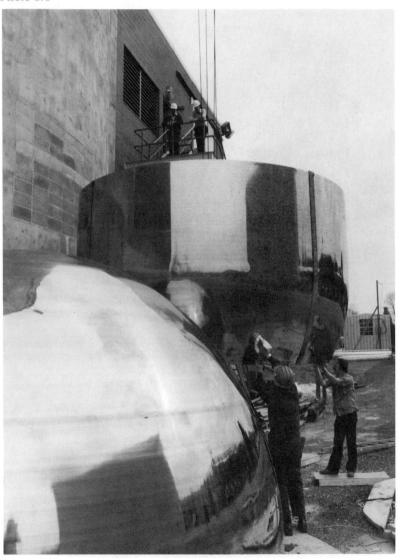

all service repair departments. A parts catalog that uses photography to show detailed illustrations of parts is less expensive to produce than one that uses artist sketches. Many parts may be airbrushed for catalog use.

A large market, and one that is growing every year, is the "how to do it" market. Almost everything printed needs illustrations: how to grow this, how to

Photo 8.4

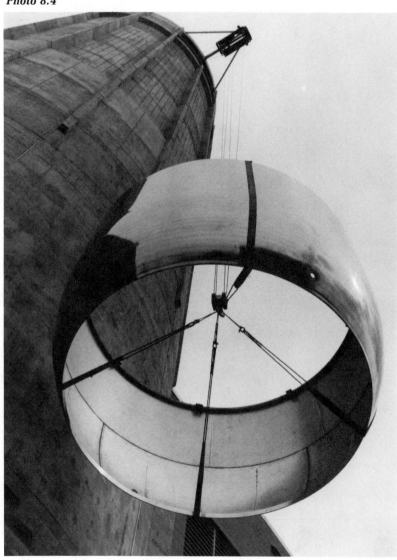

build that, how to do anything. Both books and magazines need illustrations. Textbooks are updated every few years and often require photographs.

There are many areas that are related to the assembly series. Construction photos are an assembly of offices, warehouses, or homes. Before construction can begin, a plant site survey should be done, with photographs showing the lay of land,

Photo 8.5

sewers, railroads, roads, and power availability. Even an aerial photograph could be used. A photograph to illustrate a report to executives can alleviate writing pages and do a better job. Photographs can be used for insurance documentation to show that proper construction procedures were followed. In offices and production areas

Photo 8.6

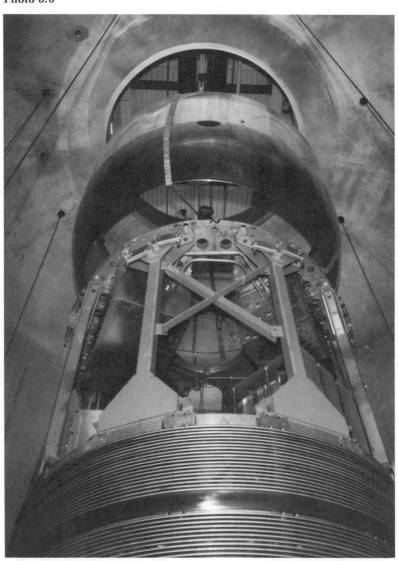

a flow layout illustrated with photographs will help in streamlining production. Proper loading of trucks, trailers, or boxcars could be illustrated with photographs. The handling of dangerous chemicals or materials, such as radioactive elements, should be demonstrated with photographs. Continuing education is a large market

Photo 8.7

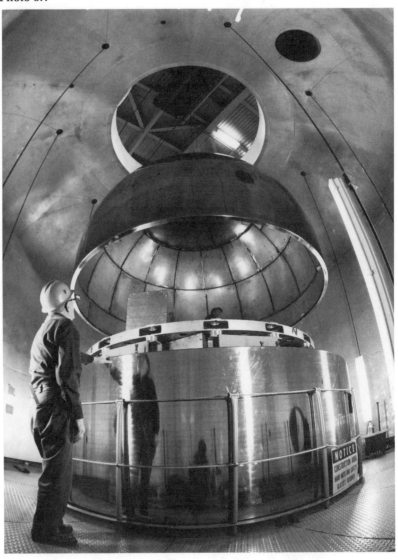

area for photography. Safety training utilizes photography, and if vendors cannot take equipment to a location for demonstration, photography can illustrate what the equipment can do.

Photos 8.2 through 8.8 Photographic coverage of the assembly of an apparatus at Holifield Heavy Ion Research Facility. (Courtesy of Oak Ridge National Laboratories.)

Photo 8.8

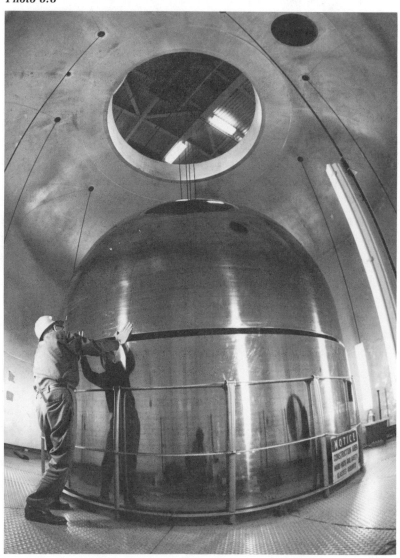

TECHNIQUES

If at all possible, the photographer should be conversant with the procedures of an event that is being photographed. If not, a person with that specialized knowledge should be on hand to "call the shots." Keep the background simple, if possible. The less there is to compete with the process, the more likely the viewer will pay attention. Try not to change the background during a series. This could disorient the viewer. Move in close so that there is no extraneous background.

Use a normal lens if possible to keep distortion from altering the subject. Try not to change the focal length of your lens during a series. Again, this could cause confusion.

Above all, be sure that everything is clearly presented and shows what needs

Photo 8.9 *Intermediate product assembly at the experimental facilities of Oak Ridge's electron linear accelerator. (Courtesy of Oak Ridge National Laboratories.)*

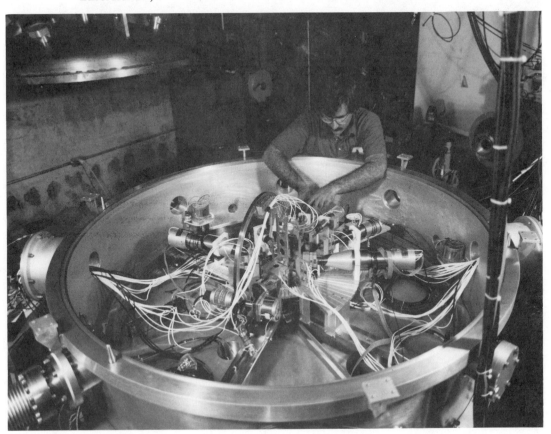

to be shown. There should be no hidden action. If hands are in the way or the view is obscured by objects, a photograph is useless.

The tonal quality of the object should match in all the photographs in the series. The object did not change, so the tone should not either. Industrial photographs require a high degree of print quality so that information can be extracted from them.

Lighting will be dictated by the event more than anything else. The three-point lighting method illustrated in Chapter 6 is very appropriate in a production situation where time and movement are limited.

Photo 8.10 *Including workers involved in product assembly provides scale and human interest. (Courtesy of Oak Ridge National Laboratories.)*

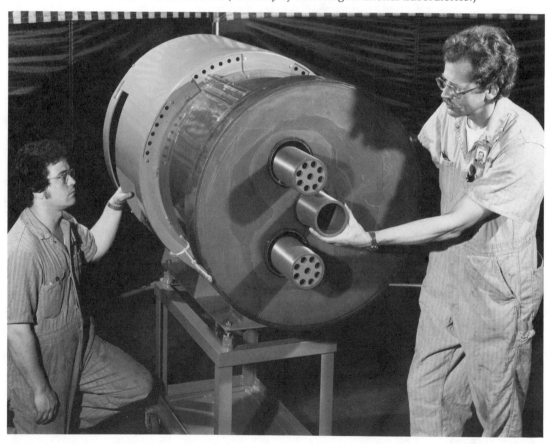

SUMMARY

Try to imagine books and magazines or training manuals without photographic illustrations. The importance of assembly photographs then becomes obvious. There are large markets in the "how to do" areas which rely on photographic illustrations. Keep the photographs simple without distracting backgrounds for effective "show and tell." Above all, show what needs to be shown.

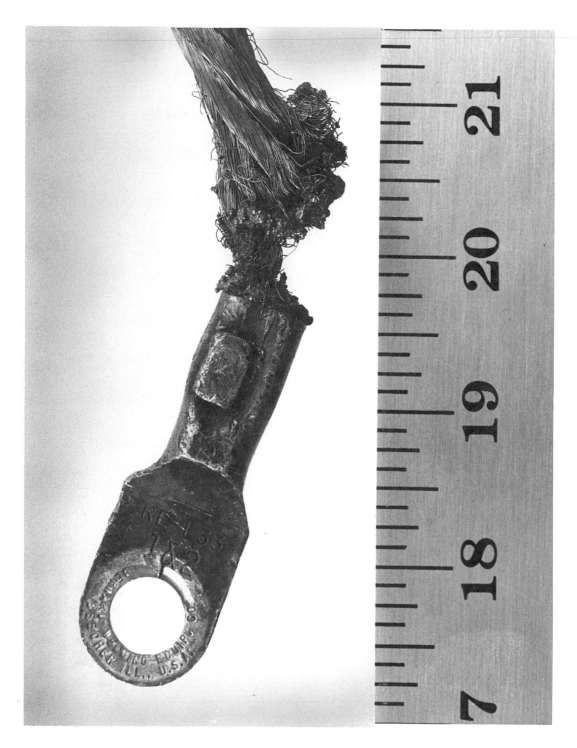

Photo 9.1 Damaged welding cable. (Courtesy of Rod Balsar.)

Chapter 9

Damaged Objects

OBJECTIVES

Upon completion of this chapter, you should be able to:

- List areas where damage photography is used.
- Define nondestructive testing.
- Tell why a scale is important and what type of scale is most effective.
- Describe various things to look for in photographing damage.

INTRODUCTION

Photography of damaged objects is an area of great importance to the industrial photographer. Large sums of money could depend on accurate presentation of damage caused in a myriad of ways. The subjects come in all shapes and sizes, from thumbnail to the size of the space shuttle photographed from Earth with special equipment to show missing heat tiles.

USES

There are many areas in which damage photography can be used. An obvious one is to document shipment damage. Frequently, goods are damaged in transit. The damage should be photographed immediately upon delivery for use in the insurance

claim. Other types of damaged goods—automobile wrecks, train wrecks, virtually any mishap or accident—should be recorded if possible for insurance purposes.

In research areas, photography is used to record equipment failure caused by a part breaking. This may be an intentional act called *nondestructive testing*, where a part is tested to its breaking point for *wear and stress studies*. Failure studies rely heavily on photography to supply a sample to an expert to find out what went wrong.

In many cases a photograph of broken parts can be sent to a vendor for replacement if the part's number is not known or the piece of equipment is no longer made. The photo, with proper measurements, might allow a discontinued piece to be fabricated in the machine shop.

Damage photographs should accompany accident reports to management and to insurance companies. Photographs should comprise a part of the record-keeping activities associated with a company's archives.

Photo 9.2 *This pressure vessel was intentionally damaged in a procedure called "nondestructive testing." (Courtesy of Oak Ridge National Laboratories.)*

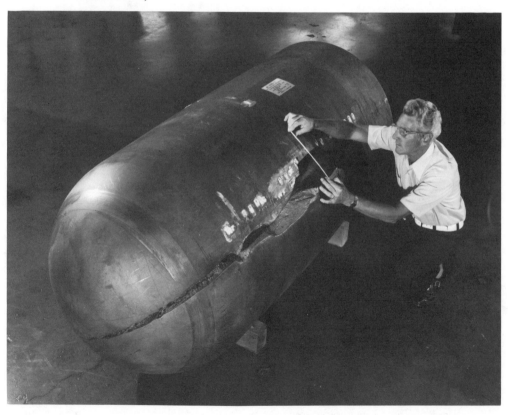

Photo 9.3 *Fire damage photography should accompany reports to management and insurance companies.*

TECHNIQUES

Each damage photograph is a different case. You may get by with available light, one fill flash, or a complicated lighting setup. Frequently, damage has to be photographed in bad lighting—even at night. It is not always possible to transport the subject to a studio. Photography should be carried out under the best possible lighting

conditions, because it is often important, as in the case of material damage, to obtain a record of the exact condition. When the damaged condition is liable to change, a photograph of the situation will prove valuable later—for example, when there is corrosion at a fractured surface, or when cleaning operations are conducted, or in order not to interrupt production.

Everything from truck size to macrosized, from a smashed fender to a failure in a printed circuit board, may need a damage photograph. The major factor is that

Photo 9.4

you *must show the damage clearly*. Large sums of money could depend on your presentations.

Use a normal lens for a normal perspective. A photo that is obviously distorted is useless for analytical purposes. Light for maximum detail in the damaged area.

Photos 9.4 and 9.5 In damage photography, a gray card is useful for color correction. A nondamaged product could be shown with a damaged one for comparison.

Photo 9.5

Cover all angles of the damage. Record a long shot, a medium shot, and a close-up shot of the damage.

Always use a scale. This is very important for showing the relative size of damage. An extreme close-up without a scale can make a crack in a circuit board look like the Grand Canyon. On large objects, use a hand or a person standing by the part for comparison. This will show relative size. If measurements are to be taken, an accurate rule needs to be used.

Bill Hyzer[1] finds that a circular scale is "much more practical than a linear scale for many other routine applications involving three-dimensional scenes that may require quantitative reconstruction from their photographic images." He cites the following two reasons: (1) the plane of the circle does not have to be aligned parallel to the plane of the film in order to provide a quantitatively useful scale of

Photos 9.6 through 9.8 *Although not the same accident, coverage should include long, medium, and close-up photographs of the damage.*

Photo 9.6

Photo 9.7

Photo 9.8

reference, and (2) the distorted shape of a circle when it is viewed obliquely is indicative of the viewing angle. Hyzer also advises: "In legal cases, photograph the scene both with and without the circular scales present to avoid later arguments that the scales might be obscuring critical details in the scene."

Photo 9.9 *For legal cases involving personal injuries, try to include a scale and a color patch for analytical purposes.*

It is a good idea to put in your camera case several types and sizes of scales to include in scenes. Make them with both black letters on a white field and white letters on a black field.

SUMMARY

Often, a good photograph of a damaged object will convey more than words about what went wrong. Good-quality photographs are required. These should have maximum detail, cover all areas of damage, and include a scale for reference.

REFERENCE

1. Hyzer, William G. (1986, January). "The Use of Circular Scales in the Perspective Grid Technique of Making Photographic Measurements." *Journal of Forensic Sciences*.

Photo 10.1 Scanning electron microscope image of pollen. (Courtesy of Oak Ridge National Laboratories.)

Chapter 10

Close-Ups

OBJECTIVES

Upon completion of this chapter, you should be able to:

- Define the close-up terms: close-up, photomacrography, macrophotography, photomicrography, microphotography.
- Explain various equipment used in close-up work.
- Explain factors affecting lens selection.
- Be familiar with the math used to figure magnification, exposure factors, and effective aperture.
- Describe advantages and disadvantages of various lighting arrangements.
- Explain how depth of field, magnification, and aperture are affected by close-up photography.

INTRODUCTION

In today's industry, the close-up photograph is becoming increasingly important due to the trend toward miniaturization. Today's machines are a combination of crude metal, high precision, and delicate computerized construction. Photography has also entered this age of smallness, with photographs ranging in magnification from extreme close-ups to the scanning electron microscope studies that thrill the viewer with worlds of unseen beauty.

There is much confusion on terminology when we enter the world of the small. *Close-up photography* may be defined as taking photographs closer to the subject than is normally possible with your regular lens. Some describe it as making a photograph up to a magnification of 3 : 1. Beyond this we have *photomacrography*, which is photographing from 1× up to 50× magnification. Many use the term macrophotography to mean extreme close-up, when in fact *Macrophotography* refers to the making of large photomurals or larger-than-life photographs.

There is also confusion between the terms "photomicrography" and "microphotography." *Photomicrography* is making images through a microscope, while *microphotography* refers to the making of microfilm, microdots, microfiche, or other small photographs. A photomicrograph is always a two-stage process. The microscope objective projects a magnified image of the subject, and this enlarged image is projected onto the film by an eyepiece.

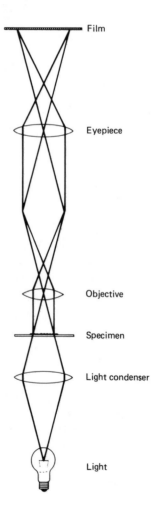

Diagram 10.1 Photomicrography
is a two-stage process.

Film

Eyepiece

Objective

Specimen

Light condenser

Light

TOOLS

In industry the 4 × 5 camera is still the principal camera in use. This is primarily for the quality it produces. In the popular press much of the equipment and discussion of close-up work centers around the 35mm camera. For this reason, in the following we mention only briefly 35mm and $2\frac{1}{4}$-inch format techniques and equipment, to provide general knowledge of what is available. The main focus is on the large format.

With close-up photography, the need for a good, stable tripod is paramount. At extreme magnifications the slightest shake or vibration will ruin the results. Several brands of tripods are made in which the legs can be positioned flat on the ground, allowing the camera to be a few inches above a subject placed on the floor.

As with any lens, try to use a lens shade to prevent extraneous light from

Photo 10.2 This close-up photograph of a high-pressure experiment was recorded with a 4 × 5 view camera. (Courtesy of Oak Ridge National Laboratories.)

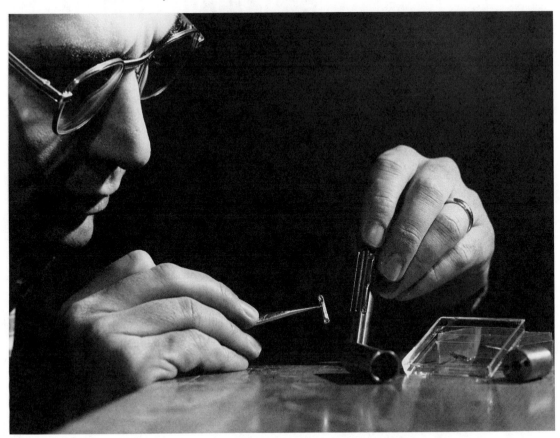

Photo 10.3 *With extreme close-up photography, excellent-quality optics are required to produce good results. (Courtesy of Oak Ridge National Laboratories.)*

entering the lens. Cleanliness is a must. Imagine magnifying a piece of dust a few times and you get the idea. Lens tissue and cleaner should be in every camera bag. Canned air is a help in dusting lenses, and a camel's-hair brush will come in handy. Besides a lens hood and clean optics, a good locking cable release is a necessity to prevent camera shake when tripping the shutter.

Lenses

The lens is the heart of the camera system. Without good-quality optics, the resulting image will be a very poor-quality photograph. With today's computer-designed lenses, quality is being improved continually. The normal lens is designed for average use. When it is extended or focused on objects closer than 25 to 50 times the focal length, edge sharpness begins to suffer from curvature of field. When it is stopped down to gain better edge sharpness, diffraction is introduced, which is the bending action of the light as it passes through a small aperture. This causes a loss

Photo 10.4 *Specially designed lenses called macro lenses can be used to photograph objects up to $\frac{1}{2} \times$ magnification without extensions.*

of sharpness. One way to improve the quality is to reverse the lens and use the rear element as a front element. The optical characteristics will show marked improvement and the flatness of field increases. When using a prime lens, use the lens in the infinity position; otherwise, edge sharpness decreases. It is also wise to focus the lens at the aperture that is needed. Sometimes there is a focus shift when stopping down after focusing wide open.

In addition to reversing a prime lens, use another prime lens in front of the prime lens to increase magnification. For example, by using a 35mm reversed lens coupled by an adapter ring to a 150mm lens, the magnification will be $4.3 \times$. Magnification can be calculated by dividing the length of the reversed lens in front, into the length of the normally mounted lens. The normal lens should be used at the widest aperture to eliminate vignetting.

There are specially designed lenses for close-up work. These are termed *macro lenses* and allow a $\frac{1}{2} \times$ magnification without optional extensions. These give better quality and more flatness of field than the normal lenses. Many are used as normal lenses, as they are designed to focus to infinity. The lenses that are designed for

precision macro work are relatively expensive. The famous Zeiss Luminars are in this class.

One lens that is designed for maximum flatness of field and one that makes an excellent lens for close-up work is the enlarging lens. They have extremely high resolution and maximum flatness of field, have good contrast, and are designed for use at higher magnifications than the normal camera lens. They also have superb color corrections. By using adapter rings or getting a machine shop to make an adapter, the lens can be mounted onto a lens board or, better yet, onto a shutter to control the exposure. By using an enlarging lens designed for 35mm or 120 film, the additional extension throws back a longer cone of light and a larger image circle that often covers the larger format. An instant print test will show if the circle of illumination is large enough to cover the film. The lens selected depends on the magnification needed and the length of the rails of a view camera. The following formula will tell whether there is enough extension:

$$V = (M + 1) \times F$$

where V is the extension, M the magnification, and F the focal length.

Another type of lens designed for close-up work, but which is of poor quality, is the supplementary lens. These lenses screw onto the main lens and alter its focal length. They are rated in diopters, which is the reciprocal of the focal length in meters. For example, a +4 diopter has a focal length of $\frac{1}{4}$ meter or 250 mm, and a +2 diopter has a focal length of $\frac{1}{2}$ meter or 500 mm. To obtain the best results as far as edge sharpness is concerned, you must stop the lens down to f-11 or f-16. To determine the magnification with a supplementary lens, use the formula

$$M = \frac{F}{Fc}$$

where M is the magnification, Fc the focal length of the supplementary lens, and F the focal length of the lens. Thus when using a +4 diopter lens on a 50mm lens, M = 50 mm/250 mm = $\frac{1}{5}\times$.

Extensions

There are two main devices for extending the lens for close-up work besides the reversing adapter mentioned earlier. They are extension tubes and the popular bellows. On the larger-format cameras which already have a bellows, accessory rail extensions are available where additional bellows lengths can be used. Extension tubes come in varying fixed lengths and extend the lens out from the body of the camera. At one time a sliding tube was used, which may still be available.

Bellows on rails for small-format cameras is the lens extension device chosen by most photographers. They provide a variable amount of extension and many have adapters for slide duping and macro stands for small subjects.

Photo 10.5 *A view camera with an extended rail will allow the photographer extra bellows extension for close-up photography. (Courtesy of Oak Ridge National Laboratories.)*

TECHNIQUES

In any photograph, lighting is of prime importance. It is the lighting that portrays perspective, dimension, dictates mood, and controls the recording of texture and details. The lighting must therefore be chosen carefully to meet the needs of the subject. The particular type of lighting is less important than correct use of the equipment available.

There can be no general rules as to lighting, as the subjects vary so greatly. There are, however, some general techniques which will be discussed later that photographers in the close-up area have found to be of use. When working in a small area, *the most essential aspect is the use of light sources that compare to the size of the subject.*

Lighting sources of various types are used in close-up work. Microscope lamps, miniature spotlights, small strobes, ring lights, reflectors, and background illuminators make up the equipment list. Regardless of the equipment used, the foremost

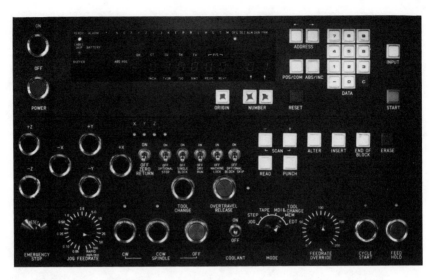

Photo 10.6 *A close-up of a control panel used for instructional purposes required soft, even lighting.*

objective should be to illuminate the subject for optimum detail while retaining true proportions. The lighting should create the illusion of dimension.

The microscope lamp works well for small-object photography. The high-intensity beam can be controlled by adjustable condensers or with a rheostat. Larger lights can ''cook'' your subject, melt plastics, and so on. They are also more difficult to control on a small scale.

Flash is a big help in location close-up work. They are light in weight and have a large output of light. They also stop some camera shake due to wind or pushing the cable release too hard. It is recommended that battery models be used. Finding a recharging plug in the middle of the field may put a photographer out of business.

A close-up ''rig'' can be made using two small strobes on a camera bracket. One is placed close to the lens and the other is placed at a 45-degree angle to the subject. A neutral density filter is placed over one strobe to achieve a lighting ratio. It is interesting to note that the exposure with this system will not vary from $\frac{1}{5}\times$ to $2\times$ life size. The reason for this is that as the unit is moved closer for higher magnification, light is lost due to the *inverse-square law*. This is overcome by bringing the flash units closer. Moving back for less magnification loses less light and at the same time moves the flash farther away, which means that the same exposure is applicable for a wide range of magnifications.

When testing the system, use a gray card, and in actual practice take into consideration the reflectance of the subject. Mathematical formulas cannot take into consideration all factors involved with a specific situation. It is always good practice to take a test shot and to bracket the exposures.

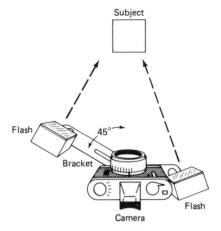

Diagram 10.2 *A close-up rig can be made by using two small strobes on a bracket.*

Photo 10.7 *A lens equipped with a built-in ring flash was used to record a new dental procedure. (Courtesy of Christy Price.)*

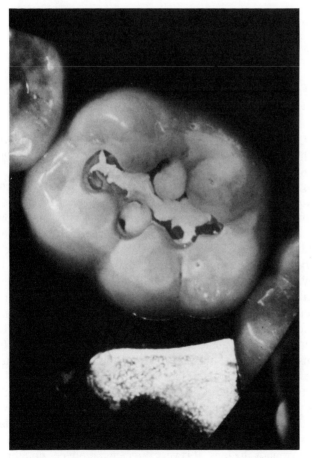

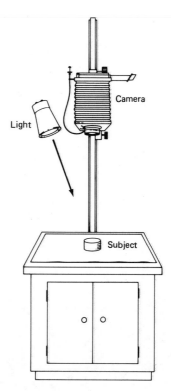

Diagram 10.3 *Directional lighting.*

The ring flash is very popular in industrial photography. The device allows shadowless, frontal lighting that penetrates recessed areas very well. One drawback is the doughnut-shaped highlights.

The rules of good lighting do not change when working in a close-up arena. The rule "*one sun, one shadow*" still holds true. The main, directional light provides adequate modeling for numerous subjects. To appear natural, the light should come from above the subject at about a 60-degree angle. Shadows can then be softened with reflectors or with additional lights. The fill light should be placed as close to the camera lens axis as possible and it should be about one-third as intense as the main light; otherwise, it will cast additional shadows that are unattractive.

Directional light creates interesting effects, sharp shadows, and higher contrast than the ambient, nondirectional quality of the totally diffuse tent lighting. The main light establishes the direction of the source and the dominant shadow direction. The fill lights are used to lighten the shadow areas to a ratio that can be recorded on film. The background light is used to separate the subject from the background. These three lights are the backbones of any good lighting.

Lighting direction plays a large role in the depiction of a subject. Front light, as close to the lens axis as possible, provides a direct source with minimal shadows. It is good for penetrating deep recesses. Because it is a straight-on light, the glare factor is high, and thus it would not be good for highly reflective material. The ring light is a circular light that surrounds the lens. It is very direct and produces doughnut-

118

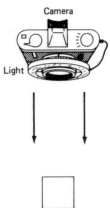

Camera

Light

Subject **Diagram 10.4** Front or ring lighting.

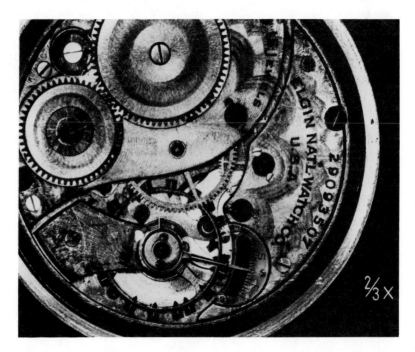

Photo 10.8 *Some cameras are equipped to imprint relevant data on the negative for technical reference. (Courtesy of John J. Kommelter.)*

shaped highlights that may be too distracting; however, it is excellent for highly detailed subjects.

Directional lighting produces shadows which may be needed to illustrate form. The best way to obtain sharp directional lighting is to use a focusing spotlight. The minispot or *inky-dink* serves well. The shadow may be too strong with only one light. A fill may be used to soften this shadow. Reflectors should not be overlooked

to put a small amount of light where needed. Reflectors can be paper, cardboard, mirrors, or of many surface textures. By *feathering* (using the edge of the light cone) the main light you can soften the main and still bounce it into a reflector for soft shadows. Even the most delicate opaque subjects, including highly reflective ones, can be photographed with this technique. Shadows are minimized, not eliminated. A broad-beam light instead of a spot should be used, as it has a softer quality. Additional lights can be used for fill instead of reflectors. Be careful not to overlight and cast a secondary shadow or a shadow within a shadow. Both appear to be unnatural. Usually, one light should be placed lower than the main and generally on the camera axis.

Side lighting produces the maximum in texture and the feeling of depth by producing elongated shadows. The light should be placed even with the subject's top edge. A fill near the camera will lighten the shadows for more detail.

With highly reflective subjects, a tent may be the answer. Jewelry, silverware, ball bearings, gear wheels, and chrome need the even lighting of a tent; otherwise, the reflections from the surroundings may be too distracting. Tents can be constructed from paper, vellum, eggshells, or milk jugs. Generally, light placement around the tent is not critical, but placement in the vertical plane may affect the light entering

Diagram 10.5 Side lighting.

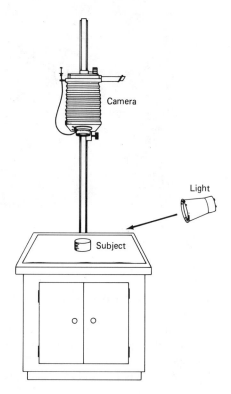

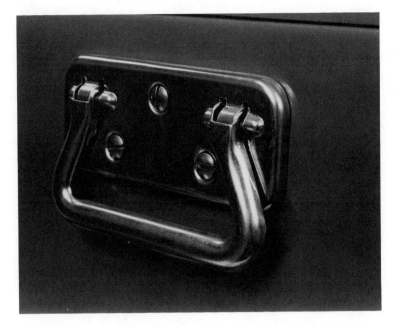

Photo 10.9 *Highly reflective objects need a soft, diffused light source or tent-type lighting.*

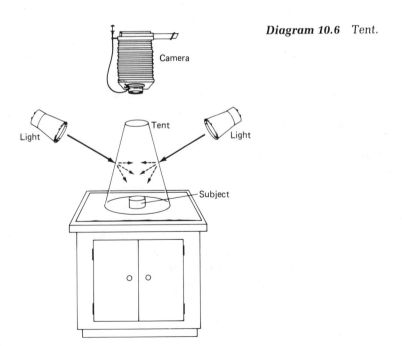

Diagram 10.6 Tent.

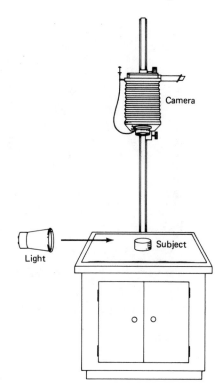

Camera

Light

Subject

Diagram 10.7 Rim lighting.

recesses. Accents can be added by putting a hole in the tent and letting raw light strike the subject.

Rim lighting is used in portraits for photographing profiles. In close-up work it can be used to photograph the leading edge of many subjects. A focusing minispot should be used and it should be placed low and close to the subject to illuminate the leading edge or outline.

In industry the light table is a mainstay for providing transmitted light for photographing transparent and translucent subjects such as plastics, glass, or some medical specimens. By placing reflectors above the light, a fill will result. By controlling the intensity it is possible to obtain a soft fill with a shadowless background. The subject can be placed on a sheet of plate glass and raised or lowered toward the illuminator to control intensity or a simple rheostat will suffice. By placing a *gobo* just large enough to cover the subject, the result is the classic *darkfield illumination*. This method is ideal for delicate, transparent subjects with surface detail. By using a direct light at an oblique angle from the rear and the darkfield in place, we have "oblique darkfield lighting," which is good for medical and biological specimens.

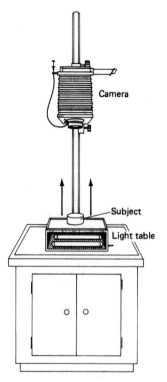

Diagram 10.8 Light table.

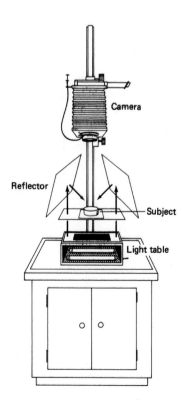

Diagram 10.9 Darkfield lighting.

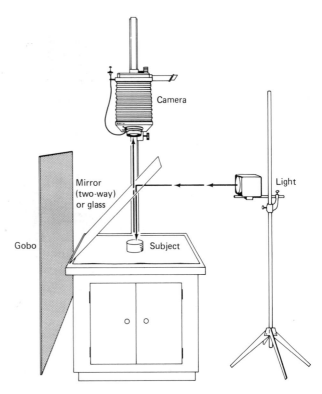

Diagram 10.10 Axial lighting.

Another lighting system used frequently in industry is *axial lighting*. This provides a direct light source with glare-free tones. A focusing spot is placed to shine into a piece of plate glass placed at a 45-degree angle above the subject. The camera is placed to photograph through the glass on an axis with the light after it hits the subject and passes through the glass. This lighting is excellent for reproducing reflective relief objects such as coins and smooth, flat reflecting surfaces.

EXPOSURE

Determining the proper exposure in close-up work is extremely important. The in-camera meter has a distinct advantage over the hand-held meter in that it calculates the bellows extension and filter factors automatically. The view-camera user can use a meter designed to be placed at the film plane like a holder or figure the exposure with mathematics. The general rule is: If the object is closer than 10 times the focal length of the lens, calculate an exposure increase. The EF formula below is one form of calculation. After figuring the new exposure, figure for reciprocity. This is an effect inherent in the film that causes it to become less sensitive to light the more

Photo 10.10 In extreme close-up work, obtaining the proper exposure with a view camera requires accurate mathematical calculations. (Courtesy of John J. Kommelter.)

it is exposed to light; thus one must expose longer. Check the film manufacturer for correcting for reciprocity. With color films there will be a color shift due to the long exposures. Check each film's data sheet for corrections.

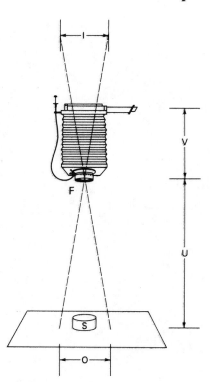

Diagram 10.11 *Close-up
measurements. I = image size; O
= object size; U = subject-to-lens
distance; V = lens-to-film
distance; F = focal length of lens.*

Exposure Factor

All exposures in the close-up realm require correction from the value indicated by the hand-held meter. The one exception is when you are using supplementary lenses. To calculate an *exposure factor*, the following equation is used:

$$EF = \frac{V^2}{F^2}$$

where *V* represents the film-to-lens distance and *F* is the focal length.
 A variation of this formula is used to arrive at a corrected exposure time.

$$NE = OE \times \left(\frac{\text{image size}}{\text{object size}} + 1\right)^2$$

where NE is the new exposure and OE is the old exposure.
 The image size can be the width of the film area being used; in large format this would be 4 inches. If a ruler is placed in the subject plane and the length observed

through the ground glass, measure directly the object size. A simple example is an OE of 1 second on an incident meter. We have a 4-inch image and we rack the bellows out to get a 1:1 image or a 4-inch object size. Thus

$$NE = 1 \times \left(\frac{4}{4} + 1\right)^2 = 1 \times (1 + 1)^2$$

$$= 1 \times (2)^2 = 1 \times 4 = \text{new exposure of 4 seconds.}$$

Guide Number

Nothing is better for calculating correct flash exposure than the new automatic, through-the-lens systems now being marketed. This corrects for light loss due to bellows extension and for any filtration that might be used. However, the large-format camera does not yet have this feature. Thus the photographer will need to calculate the exposure. One problem is that the standard GN formula does not work, due to the change in performance of the aperture. Use the *effective aperture* to calculate the exposure with the GN formula.

$$D = \frac{GN}{EA}$$

where D is the flash-to-subject distance, GN the guide number of the flash, and EA the effective aperture.

TECHNICAL MATTERS

All industrial photographers must be aware of the following topics, even though they are complicated. What follows is only a brief view; it is suggested that a good book on optics be consulted for more detailed information.

Depth of Field

All the difficulties in close-up work seem to lie in the area of limited depth of field. It must be emphasized, however, that depth of field is not affected by the choice of focal length (provided that the image remains the same size); this is a function only of magnification. As magnification increases, depth of field decreases very rapidly. Focal length can influence within limits, image sharpness, and resolving power. Depth of field can be calculated with the formula

$$DOF = 2c \times f \times \frac{(M + 1)}{M^2}$$

Photo 10.11 Obtaining adequate depth of field is difficult in close-up photography.

where DOF is the depth of field, c the circle of confusion, f the f-stop, and M the magnification. This formula shows that depth of field depends only on the f-stop and the magnification. The focal length does not enter the calculation. *It does not matter whether a given magnification is produced with a long- or a short-focal-length lens; the depth of field is the same in both cases. Depth of field is a relative value which depends entirely on the size of the circle of confusion, which is an agreed-on value permissible for a particular format.*

Magnification

Magnification or the degree of enlargement is usually determined by a ratio of the image size to the object size. This can be shown with the equation

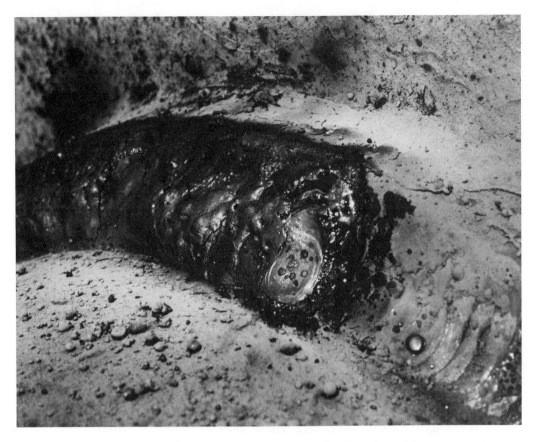

Photo 10.12 *Extreme magnification of a weld.*

$$M = \frac{I}{O}$$

where M is the magnification, I the image size of the ground glass, and O the object size. Thus if the object is 1 inch long and we have a 4-inch image on the ground glass, we have

$$M = \frac{4}{1} = 4\times$$

Optically magnification is related to the amount of extension of bellows and the lens used. The equation that follows shows this relation.

$$M = \frac{V - F}{F}$$

where V is the total extension (focal length + bellows length) and F is the focal length. Thus a 2-inch lens and an 18-inch bellows *draw* (extension) would yield

$$M = \frac{20 - 2}{2}$$

$$= \frac{18}{2} = 9\times$$

If we can measure the distance from the object to the lens, we can obtain the magnification thus:

$$M = \frac{F}{U - F}$$

where U is the subject-to-lens distance. A 50 mm lens with a subject distance of 100 mm would yield

$$M = \frac{50}{100 - 50}$$

$$= \frac{50}{50} = 1\times$$

Effective Aperture

One of the results of extending the bellows is that the aperture is no longer what the scale says it is. The f-stops are calculated at the infinity position, thus when the lens is extended, the numbers change. The formula

$$EA = f \times (M + 1)^2$$

where EA is the effective aperture, f the original f-stop, and M the magnification, calculates the effective aperture. If we have an original f-stop of f-8 and a $4\times$ magnification, the effective aperture is

$$EA = 8 \times (4 + 1)^2 = 8 \times (5)^2 = 8 \times 25 = \text{f-120}$$

Although set at the f-8 mark, the aperture is acting as if it were f-120.

Generally, the effective stop will not be used; rather, the exposure will be calculated by means of the exposure increase factor (EF). It is advisable to be aware of the effective aperture because it affects the exposure time and the resolving power. This stopping down results in considerable loss of sharpness as a result of diffraction.

Optimum Aperture

Based on the discussion above, it can be seen that from a certain point onward, depth of field can be increased by stopping down only at the cost of general sharp-

ness. There is a point of ''optimum sharpness'' for a particular lens aperture. The rule states: *The circle of confusion resulting from diffraction must not be greater than the permissible circle of confusion appropriate to the format.* This rule sets a definite limit to stopping down which must not be exceeded if optimum image sharpness is to be retained. This can be stated as:

diameter of diffraction disk = diameter of circle of confusion

$$f \times (M + 1) \times 10^{-1} = c$$

The stop that fulfills this requirement may be termed the *optimum stop:*

$$f_{opt} = \frac{c \times 10^3}{1 + M}$$

Photo 10.13 *The "optimum aperture" provides maximum depth of field in this photograph of the surface of the crystal ball spin spectrometer used in heavy ion research. (Courtesy of Oak Ridge National Laboratories.)*

Provided that the optimum stop is used, the depth of field is exactly the same for all formats *as long as the same area of subject is included.* As far as depth of field is concerned, no one format has an advantage over any other. Diffraction behaves in exactly the same way for all formats. The only way in which a small format gains is in exposure time. A large format requires a considerably longer exposure than a small one. Provided that the same depth of field is required and the same subject area is covered, exposure times will be in exact proportion to the area of the format.

SUMMARY

New worlds open up with close-up photography. With it comes many problems in optics, exposure, and lighting. A full understanding is necessary for the industrial photographer so that when problems arise, a solution can be determined.

For easy reference, the formulas that were used in the preceding discussion are grouped in Table 10.1.

TABLE 10.1 FORMULA

$V = (M + 1) \times F$	V = extension M = magnification F = focal length
$EF = \dfrac{V^2}{F^2}$	V = lens-to-film distance F = focal length EF = exposure factor
$M = \dfrac{F}{Fc}$	M = magnification F = focal length Fc = focal length of diopter lens
$NE = OE \times \left(\dfrac{\text{image size}}{\text{object size}} + 1\right)^2$	NE = new exposure OE = old exposure
$EA = f \times (M + 1)^2$	EA = effective aperture f = original f-stop M = magnification
$DOF = 2c \times f \times \dfrac{(M + 1)}{M^2}$	DOF = depth of field c = circle of confusion f = f-stop M = magnification

TABLE 10.1 (*Cont.*)

$$D = \frac{GN}{EA}$$

D = flash-to-subject distance
GN = guide number of flash
EA = effective aperture

$$M = \frac{I}{O}$$

M = magnification
I = image size
O = object size

$$M = \frac{V - F}{F}$$

M = magnification
V = total extension (lens + bellows draw)
F = focal length

$$M = \frac{F}{U - F}$$

M = magnification
F = focal length
U = subject-to-lens distance

Photo 11.1 Rolls of stock aluminum. (Courtesy of Tennessee Tourism Development.)

Chapter 11

Product Advertising

OBJECTIVES

Upon completion of this chapter, you should be able to:

- List various uses for product photographs.
- Explain starting approaches for products of different textures.
- Explain an approach to glassware photography.
- Select backgrounds to complement the product.
- Explain general lighting principles when lighting products.

INTRODUCTION

In general, when we speak of advertising, we tend to think of the glamorous type of consumer ads. In industry there is a definite advertising aspect because even industrial products must be sold. The ideal photograph tries to give the viewer as truthful a rendering as possible and in as favorable a light as can be. This is because industrial buyers are not concerned with improving the standard of living or a fantasy world; rather, they are concerned with the technical aspects of a particular piece of equipment and what that equipment will do for them. The photograph should empha-size the product's appearance, the product's ease of operation, and in some cases its performance. To give precise guidelines on every product is an impossibility due to

the many shapes, sizes, and textures that may have to be photographed. The following will give tips and techniques that will be a starting point for most any product. Then by experimentation, develop techniques applicable to many products.

USES

As with any photographic assignment, find out in advance what the photograph will be used for. It might be used for design purposes, for sales information, for catalogs, pamphlets, trade shows, or advertising in its various forms. The point is that the use may dictate the general approach or style of the photograph. It may require a straightforward view, a three-quarter view to illustrate form and dimension, or an on-location photograph. The photographer can certainly *idealize* the product by manipulation of the photographic elements of lighting, color, and perspective. The photograph should stress the product's characteristics.

Photo 11.2 *A three-quarter view was used to illustrate the form, dimension, and characteristics of this product.*

TECHNIQUES

As stated above, specific guidelines are impossible. However, products can be grouped in the following categories: products with metal surfaces; with varnished surfaces; with wood surfaces; with wood, metal, plastics, and so on, combined; made of plastic; made of leather; made of paper; made of textiles; in the form of liquids; or made of glass. Each product will be looked at from the point of type of background that is recommended, type of lighting with which to approach the subject, and special treatment by way of filtration or processing.

Metal Surfaces

Photographing metal products always presents a challenge due to the high reflectance of the surface. A background that contrasts with it would be best, such as fabric, wood, paper, or glass. The lighting has to be extremely soft and indirect. A tent made of plastic jugs for small items is good, whereas a large tent will have to be built to accommodate larger objects. In some cases a polarizing filter will help if it is placed over the light source and lens.

Photo 11.3 *Soft lighting is required for reflective surfaces.*

Photo 11.4 *Highly varnished surfaces need indirect lighting.*

Varnished Surfaces

The background should contrast with the surface texture of the varnish, that is, a matte background with a glossy varnish or a glossy background with a matte surface. Indirect lighting should provide base light, with a spot used to add accents. If there are too many reflections that cannot be controlled, use a dulling spray. A polarizing filter may be used to cut the reflections.

Wood Surfaces

Wood should be photographed against a homogeneous, out-of-focus background. This could be made of plastic, glass, or metal; or if the object is small, place it on a light table. There should be a slight contrast difference between the background and the wood. A strong main light should be used from an oblique angle to emphasize the texture. A soft fill will lift the shadows so that detail will be recorded.

Photo 11.5 Wood products should show grain and texture. (Courtesy of Tennessee Tourism Development.)

Photo 11.6 Generally, soft lighting is used with varied surfaces.

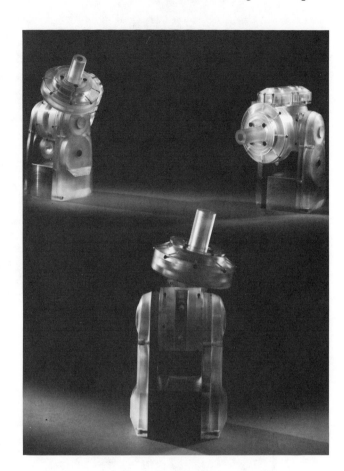

Photo 11.7 *Plastic is often illustrated with back or side lighting. (Courtesy of Oak Ridge National Laboratories.)*

Combinations

With products that have a combination of surface materials, the background will have to be constructed to complement the dominating material or the one that you wish to emphasize. Generally, a soft light will be necessary because of the varied surfaces. Accents can be used to highlight portions of the product and to light recessed parts. Generally, a polarizing filter will increase the brilliance of a combination product.

Plastic Surfaces

Fabrics and glass make nice backgrounds for plastic products. Plastics reflect only part of the light; part of the light penetrates below the surface, where it is scattered. This scattering causes the contours of the product to be diffused and the three-dimen-

Photo 11.8 *Black leather products are extremely difficult to photograph to retain texture.*

sional aspect of the object is lost. It can often be outlined only with harsh side or back lighting. In the case of unfinished parts, harsh shadows are preferable. Rim lighting works well with plastics.

Leather Products

In general the background should contrast with the surface texture. If the leather is smooth, try a fabric background; if rough, use one without a texture, such as a plain surface paper. Generally, indirect light would be preferred. A broad-beam light would allow for creating a dimension. A glancing side light will bring out the texture. A little talcum powder will bring out the texture in leather. Some leathers are best photographed in daylight. Contrast filters should be used to lighten or darken a specific leather.

Paper Products

A contrasting background should be used with paper products. A diffused, direct-lighting arrangement is best. A polarizer may cut some of the glare from shiny papers.

Photo 11.9 *A smooth background and soft directional lighting were used to photograph this fabric bag.*

Textile Products

Generally, a paper, wood, plastic, or stone background will enhance fabrics. The main light should be diffused, while a side light will bring out the texture of the fabric.

Liquids

A neutral white or gray background should be used with translucent objects. For opaque liquids a dark or black background should be tried. Back lighting is a good place to start. If the liquid is moving, or you are trying to capture the bubbles, a strobe should be used.

Glassware Products

Some objects seem to give photographers no end of trouble. Glassware is one of these; however, it need not be. The property of glass is that it both transmits and reflects light at the same time. The degree of each depends on the quality of the glass and what is in it, and it is this of which the photographer must be aware. ''The highly perceptive photographer and the beginner, alike, see through . . . see reflections in and from . . . see etching or designs upon . . . but seldom notice the object itself.''[1] Another area of which the photographer must be aware is the form of the

Photo 11.10 *Coal research apparatus. (Courtesy of Oak Ridge National Laboratories.)*

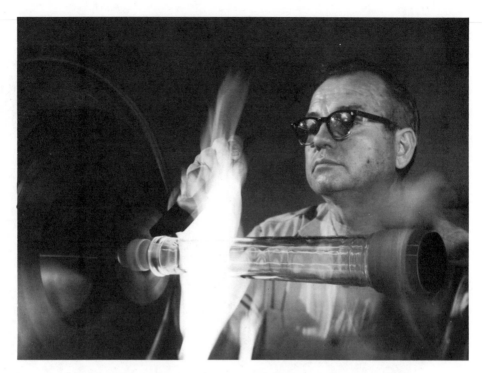

Photo 11.11 At Oak Ridge National Laboratories, a glass blower creates specialized scientific utensils. (Courtesy of Oak Ridge National Laboratories.)

glass and the shape of any intersecting objects or background. This is because of the possible distortion due to refraction.

One problem that must be dealt with early is the surroundings. To light glass with a minimum of reflections, the studio must be able to be darkened; otherwise, any light source will appear on the glassware. Outdoors the reflections will be controlled by the light angle, time of day, surroundings, and to some degree, controlled via gobos and reflectors.

Lighting. It is generally agreed that the best way to light glassware is by transillumination or back lighting. The lighting can also be from below the subject. With this method the glass stands out as a silhouette with black outlines or edges. By varying the light source from a spot to a flood, the appearance of the finished photograph will change. It is best to experiment with the degree of light coverage to see the results. A more low-key effect will result with a spotlight, and a more high-key effect will result with a broad light. The glass can be set on a sheet of white vellum to give a smooth lighting base. Many photographers use light tables made of curved plexiglass on a stand. This gives a horizonless background and provides a strong support for the glass. Of course other backgrounds can be used with interesting effects. The shower glass doors make interesting patterns to use as backgrounds.

144

Photo 11.12 Back lighting or transillumination can be used for lighting glass. (Courtesy of Oak Ridge National Laboratories.)

Photo 11.13 F-centers in KCl(71) crystals required back lighting for illumination. (Courtesy of Oak Ridge National Laboratories.)

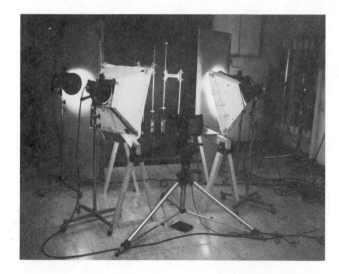

Photo 11.14

Photo 11.15

Photographic setup used to record a glass/liquid combination. (Photo 11.15 courtesy of John J. Kommelter.)

Glassware that is dark or filled with dense liquids is difficult to light by transillumination and must usually be treated like any other shiny, opaque object. In this case a tent lighting would be a good approach to start with.

With the use of back or bottom lighting a problem of flare exists of which you must be aware. Use a deep lens shade to control it as much as possible.

Accents and Highlights. To add color to an otherwise black-and-white shot, color gels can be placed over the lights. Acetate sheets of differing color can be added to the background for localized color or can be cut to the shape of the glass subject, taped to the back, to add color just to the object. Color can be added to vessel types of glassware by adding food coloring to water and filling the vessel.

Highlights can be added to the glass by shining a light into a piece of board placed to the side of the glass. The size is controlled by the size of the reflector. "A simple way to improvise such a source is to clip a sheet of mounting board to one barn door of a floodlamp and control the width of the slit of light emitted by the opposite barn door."[1] By using this method you can define the subject's edges with highlights only. Strips of paper can be added to the scene so that they reflect in the glass. This would be a good device to bring out the edges.

Photo 11.16 *Background sparkles nicely with these lead-iron phosphate glass samples. (Courtesy of Oak Ridge National Laboratories.)*

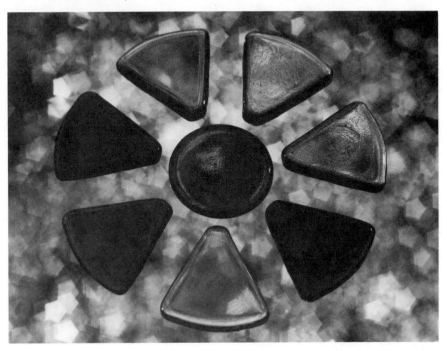

Photo 11.17 *Overhead room lighting combined with water droplets provides a nice design in creative glassware.*

Front and side lighting can be added to add sparkle, depth, and form to the glass. However, if the design includes etching, be careful of its placement so that you do not lose part of it.

BACKGROUNDS

In general, not enough care is taken in choosing a background for industrial products. Too often it is simply placed on a "sea of white." However, restraint in the treatment may be best to produce a simple, graphic design that illustrates the product effectively. In catalogs it is recommended that the product be in a neutral setting so that buyers can imagine the product in their own locations. With technical products a background of graph paper or the inclusion of a scale may be necessary to provide technical information needed by the buyer.

A fade to black, with the product in a spotlight, is a technique that is very successful with many products. The feathered edge of a broad-beam light can be used to provide a gradual fade. Gobos and flags can further control the spill on the

Photo 11.18 *This DXT equipment was photographed on location in a laboratory. (Courtesy of Oak Ridge National Laboratories.)*

background. For the best effect, the background needs to curve gently toward the rear in a horizonless manner. The steeper the sweep, the more abrupt the fade. The black area may be used for the advertising type.

Patterns may be projected onto the background with *cookaloris* or "cookies." Patterns are cut in Masonite and a spotlight is shown through them, casting a pattern onto the background. The sharpness can be controlled by the distance the light is from the pattern. Streaks of light may also be shown on the background to highlight a product, as well as halos and puddles of light to emphasize the product.

The background material need not be the paper background exclusively. The following types of products may be used effectively for a variety of products.

Blinds	Rubber mats
Painted pipes	Black tile
Black velvet	Fabrics of all types
Formica	Plexiglass
Foils	Standard seamless paper
Wood panels	Formed plastic panels
Hand-painted canvases	Construction paper
Form-core panels	

Photo 11.19 *An out-of-focus background contrasts nicely with this model of a uranium pellet. (Courtesy of Oak Ridge National Laboratories.)*

This list is very limited; your imagination is the key to a background selection. For example, even a television set can be used to create unusual backgrounds. The object is placed on a sheet of glass to reflect the TV set in the background.

LENS AND LIGHT

Lighting in general should enhance the product. If the lighting stands out instead of the product, it is a poor job. The main light is the light that sets the mood and defines the texture of the product. It must enhance the product or the advertising message will be lost. Some of the tips that follow may be used at different times to enhance the product.

Photo 11.20 *This large conveyor installation required only fill flash to give a natural appearance.*

The following is a review of general lighting principles:

1. The subject should look natural and appealing.
2. The light should compare with natural sunlight in angle and quality.
3. There should be one dominant light source.
4. Avoid double shadows.

Remember: "rules" are made to be broken. Experiment, find your own style, and fit the lighting to the product and the mood desired. Above all, think about what you are doing.

A light table with a built-in rheostat may be used to balance the main light and

the shadows cast so that the shadow is eliminated. Very dark or very light objects should be photographed on or against a neutral gray background. This lowers the contrast range and allows both shadows and highlights to be recorded on the film. Sometimes, shadows may be a problem. Try raising the object off the background, or place the object on a piece of glass suspended above the background and light the background separately. Recessed areas can be lifted by the use of small focusing spots or mirrors used as reflectors. Rim lighting should be used to emphasize the contours of the product.

With strongly reflecting products, indirect lighting should be used. Remember, though, that it is the reflection that is being photographed, not the surface. Thus, if it must be light, a white board should bounce light into the surface. The absence of light reflecting into the surface records as a black surface.

Objects with round bodies or circular frames should be photographed with a longer-than-normal lens, especially if it is placed near a border. Sometimes a wide-angle lens will enhance a product with a large linear extent in depth. If two or more products are in the same photograph for comparison purposes, a long-focal-length lens should be used to avoid distortion.

Reflectors should be used as often as possible rather than adding additional lights. It reduces the cost of electricity and bulbs, and it reduces many problems of overlighting. A reflector can be anything that reflects light, from paper to foils to fabrics. Its main job is to reduce the contrast range in a photograph. For maximum effect, the reflector should be placed opposite the main light and as close to the subject as the framing will allow.

Photo 11.21 *Large white reflector panels were used to give a smooth appearance to this toolbox.*

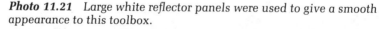

Photo 11.22 *A long-focal-length lens should be used to avoid distortion with round or circular products. (Courtesy of Oak Ridge National Laboratories.)*

SUMMARY

Although many product photographs for consumer advertisements are farmed out to "commercial" studios, the industrial photographer needs to be able to photograph products for other uses. This involves examining the product for type of construction and photographing it to its best advantage. Glassware seems to cause most photographers endless trouble, so an approach is needed to ease the dilemma of reflections and highlight placement. Background selection needs to complement the product.

REFERENCE

1. Kodak (1971). *Kodak Job Sheet 21: Glass, Handle with Care*. Rochester, N.Y.: Eastman Kodak.

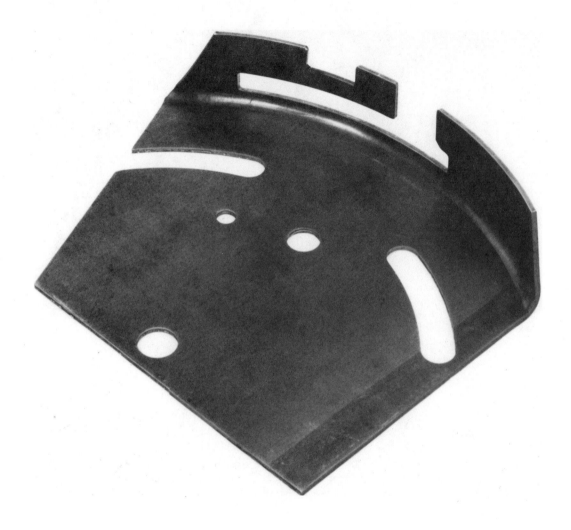

Photo 12.1 Background masking eliminates backgrounds.

Chapter 12

Special Photographic Techniques

OBJECTIVES

Upon completion of this chapter, you should be able to:

- Drop out a background with stripping film.
- Drop out a background with ortho.
- Drop out a background with opaque, pencil, and tape.
- Add titles to photographs.

INTRODUCTION

There are many times when a photograph with a pure white background is needed. Such a photograph provides a sea of white in which a catalog product appears to float. There are no distractions. When photographing a difficult product, the elimination of shadows on a plain white background is next to impossible. Not all products can be set on a light table to balance the lights and eliminate the shadows. Even if we can produce a shadowless background, whites often print as a shade of gray instead of the pure white of the paper base. Thus we need a method that will eliminate a background.

Photo 12.2 *Cutting a stripping film mask.*

STRIPPING FILM MASKS

One method of producing a mask is to affix a piece of stripping film to a negative and cut out the area covering the product. This works well with rather large objects that do not have a lot of indentations or ragged edges, and for objects located where there is a limited choice of backgrounds. One stripping film is ruby red in color and another is amber orange. Both are transparent films and both are actinically opaque to blue-sensitive photographic paper. Since cutting on the film is necessary, a 4 × 5 negative or larger is preferred. Duplicate and enlarge smaller negatives onto a direct-duplicating film.

To begin, cut a piece of stripping film the size of the negative. Peel off the film from the stock and lay it down on the base side of the negative. Be sure to roll it on to prevent air bubbles from forming. Using a sharp knife, preferably a swivel knife for curves, and on a light table, cut through the film and around the object.

Photo 12.3

Be careful not to cut into the negative. Be sure that the knife is sharp or a ragged edge will result. Use a ruler for straight lines and various French curves for nonstraight lines. The swivel knife will allow you to cut freehand curves with a little practice. After cutting, peel the film away from the product and print.

The area that is removed from the negative can be placed onto a clear piece of film base. Contact-print this onto high-contrast material to produce a mask that can be combined with the original negative (if photographed in color) and a color print made.

Photo 12.4 *Photo 12.5*

Photos 12.3 through 12.5 *Product photographs using a high-contrast mask to drop out the background.*

DROP-OUT MASKS

A studio technique for photographing small, intricate objects with a dropped-out background is the use of a two-negative technique. One is a full-tonal-range negative of the product; the other is a silhouette of the product made on high-contrast material producing a mask. The two negatives are printed in register to produce the product on a white background. It works well with color or black and white.

Place the product on as small a support as possible, since this will be opaqued out on the high-contrast negative. The smaller the support, the less opaquing that is needed. The key to a good shot is to light the two negatives separately. Light the product to its best advantage, to show maximum detail.

After photographing the product, place a white card large enough to cover the film plane behind the product. Place two lights at a 45-degree angle to illuminate the card. Be absolutely sure that no light is spilling onto the edges of the product. Make an exposure on high-contrast material at the same f-stop as the original full-tone negative. The focus could shift if you don't.

A couple of tips: Make sure that the camera is rock steady. You cannot afford to have it move between exposures. The negatives will not align if it does. Use film holders made by the same manufacturer.

Opaque any pinholes on the mask and the support using either red or black opaque. Water-based opaque should be thin enough to be brushed on, yet thick enough to cover the area completely in one application.

Photos 12.6 and 12.7 *Large objects can be isolated using opaque and tape to mask out the background. (Courtesy of Jerry Seal.)*

Photo 12.6

Photo 12.7

Photo 12.8 *To facilitate later masking, white reflector boards were placed under the intricate areas.*

OPAQUE AND TAPE

Opaque is a water-based paint that can be painted onto the negative to eliminate a background. The opaque should be of the consistency of thick paint. If it globs up, it is too thick, and if it is like water, it is too thin. It should cover the area smoothly in one stroke. It is difficult to use with intricate objects unless you have a very fine brush (numbers 00 to 0000) and a very steady hand. One nice thing about opaque is that it is water based. This means that it can be washed off the negative if a mistake is made.

Photo 12.9 *A combination of stripping film tape, opaque, and pencil was used to drop out the background of this photograph.*

When masking products with straight lines, red lithographer's tape can be used for the edges. A wax-based pencil can be sharpened to a fine point and applied to small corners or minor indentations. The rest of the negative can be opaqued with water-based opaque. Crocein dye can be used in place of the opaque; however, it is likely to streak and it is not easily removed. For the most part it is recommended that the work be done on the base side of the negative. The penciling can be done on the emulsion side, and if more tooth is needed, retouching dope can be applied.

ENLARGER MASKS

The enlarger can be used to produce masks. Enlarge the negative to the size you need on a light box and make a print. Then using a piece of red stripping film, cut out the background. The product is covered with the stripping film. A piece of high-contrast film is placed in the enlarger in place of the original negative. The light box is switched on and the high-contrast mask is exposed in the enlarger and processed. The mask is then placed in register with the original negative and a print with a white background is made.

Photo 12.10

TITLES

There are many times when a title, logo, or other message needs to be imprinted or double printed onto an image. This may be for business cards, Christmas cards, calendars, catalog pages, announcements, or other reasons. One common use is to put a label on the edge of a group photograph giving the group's name and date on the meeting, for example.

By imprinting on the photograph, multiple images with a professional look can be made. This eliminates hand lettering or rub-on type on many copies, although this is one method used to make the printing mask.

Photo 12.11

MATERIALS

The photographic material used to make the mask is a high-contrast ortho film. It is an orthochromatic film that can be handled in a red safe light. It comes in 35mm, 120, and most sheet film sizes. A reproduction film or a precision line film might also be used. Use it in the size that matches the original negative. It is preferable to use a larger 4 × 5 negative when making titles. The film is processed in a high-contrast developer. Regular red or black opaque can be used to eliminate pinholes or other ''errors'' on the film.

Photo 12.12

Photos 12.10 through 12.12 *These photographs show both a positive and a negative image and the ortho negative of the artist-drawn type.*

When it comes to the type, the press-on type available at art stores can be used. It is far superior to typewriter type and is more professional looking than hand lettering. It comes in many styles and sizes for virtually every need.

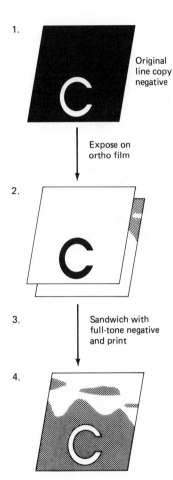

1.

Original
line copy
negative

Expose on
ortho film

2.

3.

Sandwich with
full-tone negative
and print

4.

Diagram 12.1 White titles. (1)
Begin with a black card with
white letters. (This can be made
by contacting the copy negative
made from black letters on white
board.) (2) Expose on ortho film to
produce clear base with black
letters. (3) Sandwich with full-
tone negative. (4) The result is a
print with white letters.

TECHNIQUES

When there is a reason to title a photograph, determine before it is taken where the title is to be placed. Compose the photograph to accommodate this. The background will determine whether white or black type is needed. To produce white lettering on the print, make a mask to sandwich with the negative. Place the rub-on lettering (white) onto a black card in the place where it is wanted on the print. Make an exposure onto the ortho film. This produces black letters on a clear base. When placed in register with the negative and printed, the result will be white letters.

To produce black letters, use black letters on a white card. Photograph this onto ortho film to produce a mask with clear letters on a black base. To print, expose

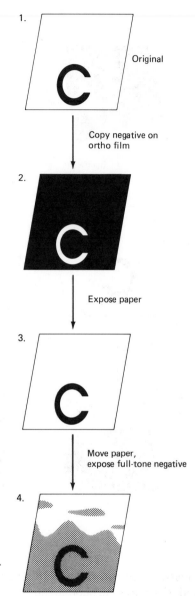

1. Original

Copy negative on
ortho film

2.

Expose paper

3.

Move paper,
expose full-tone negative

4.

Diagram 12.2 Black titles. (1)
Begin with a title card made with
rub on letters. (2) Copy negative
onto ortho film. (3) Expose paper.
(4) Move paper, expose full-tone
negative.

the paper with the original image, then remove the negative, place the mask in the enlarger, and expose just the letters in the area where it is needed. If more than one print is to be made, use two enlargers. Expose the paper to the original negative with one enlarger and then move to the next enlarger for the exposure to the letters.

With a contact printer, make a full-size mask and contact the letters or strip in a white area. Make an ortho negative the size needed, with black covering the rest of the area. Make an exposure of the original, then place the print on the contact

Photo 12.13

Photos 12.13 and 12.14 *Titles printed in with a photograph adds identification. (Courtesy of John J. Kommelter.)*

Photo 12.14

printer for the lettering exposure. This is a very good way to place a logo in a corner of the photograph. A strip of ortho film on an easel with a hinged lid to overprint a title can be used.

SUMMARY

Being able to place titles in a photograph and being able to eliminate a background in a photograph are special techniques used by industrial photographers. Learning these manual skills involves practice and patience, but they do save time and money in the reproduction stages of the printing process.

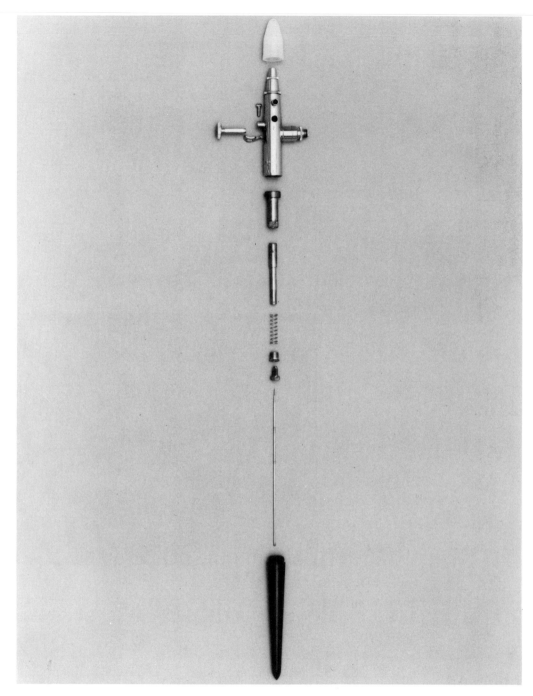

Photo 13.1 (Courtesy of John J. Kommelter.)

Exploded Views

OBJECTIVES

Upon completion of this chapter, you should be able to:

- List reasons why exploded views are used.
- Perform basic exploded-view photography.

INTRODUCTION

An exploded view is a photograph that illustrates the construction of a piece of equipment by laying out the parts in the order of their assembly. They appear to float in air, but they are in their correct order, alignment, and perspective.

USES

The technique provides information about the technical object and its function. It provides the viewer with a positive identification of the parts and an idea about its structure. When coupled with part numbers, the ordering of parts can be done by visual identification alone. These photographs are used extensively in parts manuals and instruction books, and are quite popular for demonstration and informational purposes. They can be used for the repair and assembly of products.

TOOLS

Everyone seems to worry about the proper equipment to use in given situations. Since blocking out the supports on the background with retouching is required, the largest negative possible is advisable. An 8 × 10 camera should be considered standard in an exploded view. A 14-inch lens should be a starting point. A longer-focal-length lens would be better than a wide-angle lens to avoid excessive distortion of the parts. The camera angle chosen should show the top, side, and end of most parts. This is attained by a 45-degree angle above and to the side of the layout.

With small layouts, a light box would allow you to eliminate background shadows. If a light box is not available, place the parts on a sheet of glass raised above a white background. Light the background separately to eliminate the shadows. A sheet of back-lit opal glass will give a smooth background.

One method of lighting is to use a boom spot (on flood position) for a work light directly over and slightly forward of the setup. Place two floods on either side of the camera, one slightly higher than lens level and the other at (or slightly below) lens level. This will produce an even, well-rounded lighting that is flat. The objective is to retain all the detail possible without being dramatic. If there are any shadows or dark areas, they can be lifted by using the minispots with snoots or barn doors for control.

Exposure is based on the darkest shadow. The light box should not be on when making this reading. The background exposure, if using a double-exposure method for control, should be 50 to 100 percent more than the product exposure.

TECHNIQUES

The actual photography of an exploded view is less difficult than the technique of arranging the parts. The photograph must not be too difficult from the point of view of positioning the parts. The most important aspect is for the photograph to retain clarity. Trying to include too much detail in a single photograph is a mistake. If this means showing two or three subassemblies in a layout rather than one, the effort must be made.

The piece should be disassembled and each part thoroughly cleaned. Be sure to lay out the parts in the correct order. A very bright metallic part can be sprayed with a matte spray. Some parts may need ''makeup'' for the edges to be visible or to emphasize a particular area. Black wax pencils, white grease pencils, or chalk can be used for this purpose. As much as possible, all cleanup and makeup must be done before the photograph is made to eliminate retouching, airbrushing, or artwork on the finished photograph. This reduces the overall cost of the job.

Placing the parts can present a problem. Small blocks can support the parts. Paint them a flat white so that they are easily retouched. Mount small parts on small pieces of plastic or acetate with beeswax or a hot-glue gun. Even a small part should be mounted on a base so that it can be slid into position later. Plate glass can be

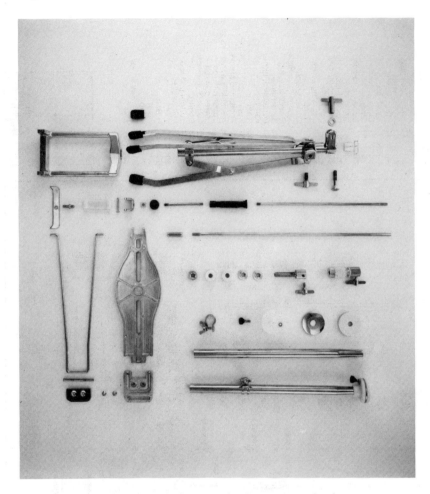

Photo 13.2 The original photograph of a parts catalog layout was photographed with an 8 × 10 camera using a 190-mm wide-field lens. (Courtesy of Henry Schofield Studio, Nashville, Tennessee.)

used as a support for heavier pieces. Glass shelves made of strips of thin plate glass can serve as a support. If reflections are a problem, especially of the edges, paint them black and opaque them out on the negative. In placing the parts to obtain the illusion of one part being higher than another, it is sometimes possible to move one part away from the camera. There is a limit to this, however, because if it is moved too far, it will diminish in size and lose its proper size perspective.

To help in the layout of the parts, use *ruled overlay sheets*. The overlay is made of evenly ruled lines on a clear sheet of acetate. It could be enlarged from a sheet of graph paper on high-contrast ortho film. This will help in keeping the rows

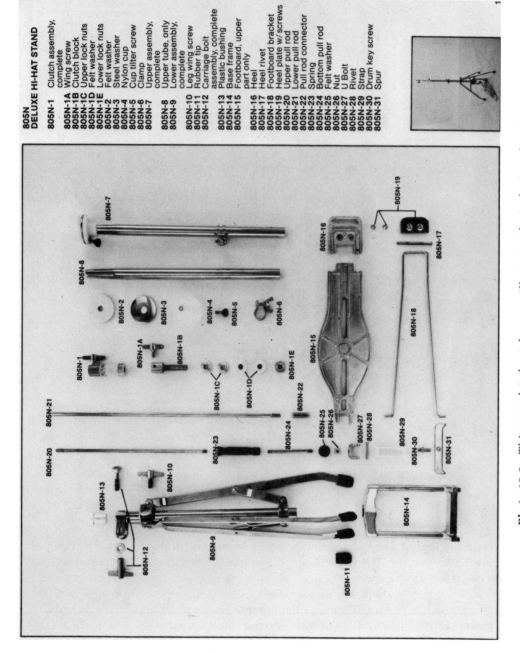

805N
DELUXE HI-HAT STAND

805N-1	Clutch assembly, complete
805N-1A	Wing screw
805N-1B	Clutch block
805N-1C	Upper lock nuts
805N-1D	Felt washer
805N-1E	Lower lock nuts
805N-2	Felt washer
805N-3	Steel washer
805N-4	Nylon cup
805N-5	Cup tilter screw
805N-6	Clamp
805N-7	Upper assembly, complete
805N-8	Upper tube, only
805N-9	Lower assembly, complete
805N-10	Leg wing screw
805N-11	Rubber tip
805N-12	Carriage bolt assembly, complete
805N-13	Plastic bushing
805N-14	Base frame
805N-15	Footboard, upper part only
805N-16	Heel
805N-17	Heel rivet
805N-18	Footboard bracket
805N-19	Heel plate w/ screws
805N-20	Upper pull rod
805N-21	Lower pull rod
805N-22	Pull rod connector
805N-23	Spring
805N-24	Bottom pull rod
805N-25	Felt washer
805N-26	Nut
805N-27	U Bolt
805N-28	Rivet
805N-29	Strap
805N-30	Drum key screw
805N-31	Spur

Photo 13.3 *This completed catalog page illustrates the inclusion of parts numbers and word descriptions. (Courtesy of Pearl International, Nashville, Tennessee.)*

Photo 13.4 *This exploded view of a thermocouple could be improved by separating the four circular components so that they do not overlap. (Courtesy of Oak Ridge National Laboratories.)*

in alignment. If you have a row going in another direction, place a second overlay going in that direction. Remember, in placing the parts, it is important that no two parts overlap. Also, the spacing between the parts should be realistic. A layout should be sketched out in advance to facilitate the placing of parts. It is best to place the parts from the rear first and work toward the front, as it is easier to keep overlaps from taking place. Because of the difficulty of moving parts while looking through the ground glass, two people are necessary.

SUMMARY

Setting up an exploded view is a time-consuming process requiring patience. Parts need to have makeup applied to eliminate expensive retouching later. Large-format equipment is suggested to facilitate this retouching in the earlier stages.

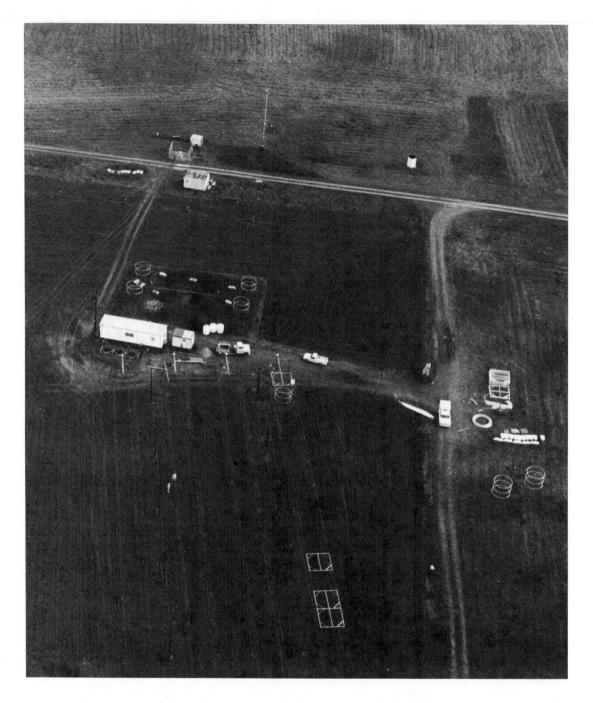

Photo 14.1 Aerial view of the environmental areas at Oak Ridge National Laboratories.

<div align="center">

Chapter 14

</div>

<div align="center">

Aerial Photography

</div>

OBJECTIVES

Upon completion of this chapter, you should be able to:

- Define vertical and oblique aerial photography.
- List several areas of application for aerial photography.
- Select the proper aircraft and weather conditions.
- Expose properly and select the correct filtration.

INTRODUCTION

It is difficult to cover aerial photography in one easy lesson, because as with other fields, specialization has left its mark. Technically speaking, aerial photography is usually thought of as a highly advanced procedure calling for special-purpose cameras, accessories, films, and developing techniques. However, it need not be; it can be a very profitable market for the professional photographer.

There are basically two types of aerial photography. In *vertical photography* the photograph is taken with the camera pointing straight down toward the ground. The camera is usually a highly specialized one from which maps are made and is beyond the scope of this chapter.

Oblique aerial photography is the hand-held type of aerial photography made from light planes and helicopters and is the type that we are primarily interested in

here. There are two types of obliques: the *high oblique*, in which the horizon line is showing, and the *low oblique*, in which there is no horizon line.

USES

There are many uses for aerial photographs. The following list of markets and uses includes both oblique and vertical images.

Urban planning

Rights-of-way

Zoning

Land utilization

School bus route surveys

Fish and game surveys

Quarried material inventory

Aircraft obstruction maps

Utility services areas

Microwave paths

Sewer routes

Highway plans

Flood control

Water reservoir volume

Golf course sites

Industrial sites

Crop inventories

Aerial mosaic maps

Industrial photos

Expansion studies

Studying overall operations

Legal evidence

Scenic aerials

Land development

Resorts and amusement parks

Photo-journalism and sports

Identifying culture and land use

Locating potential treasure sites

Electric transmission line routes

Soil differentiation and crop
 identification

Deployment and utilization of
 equipment and personnel

Identification of water bodies
 and silted areas

Differentiation of vegetation

Bare soil and emerging crops

Population studies

Land acquisition

Tax assessment

Cadastral surveys

Water pollution control

Mined material inventory

Volumetric data on excavations

Traffic studies

Subdivision sites

Pipeline routes

Irrigation studies

Earthwork computations

Dam plans and design

Waterway navigation studies

Shopping area studies

Timber inventory

Decoration and display photos

Graphic arts

Landslide studies

Construction progress

Advertising

Nature of fires

Pollution control

Real estate

Car dealers

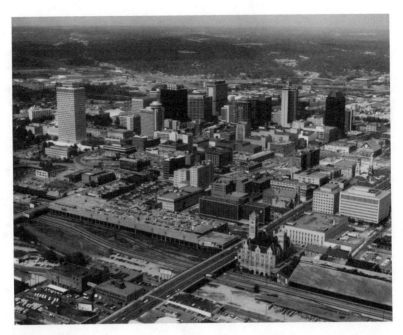

Photo 14.2

Photo 14.3

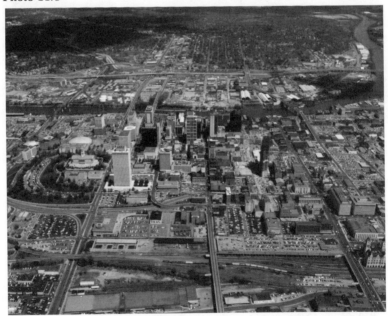

Photos 14.2 and 14.3 These two views of Nashville illustrate high-oblique photography, in which the horizon line is showing, and low-oblique photography, in which it is not. (Courtesy of Henry Schofield Studio, Nashville, Tennessee.)

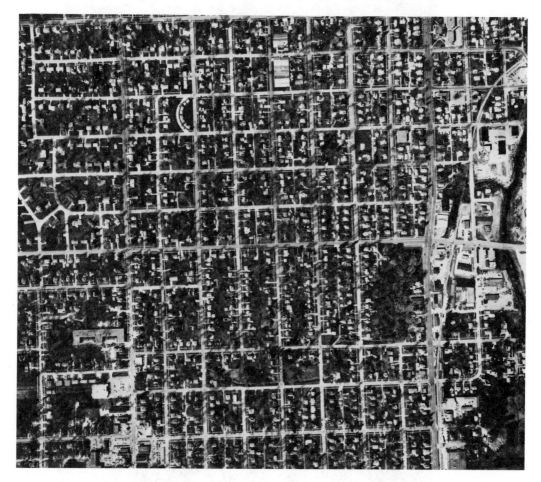

Photo 14.4 *Highly specialized equipment is needed for vertical aerial photographs. (Courtesy of Aerial Services, Inc., Waterloo, Iowa.)*

TOOLS

Plan beforehand the equipment that will be needed. Take as little as possible. Once in the air, experimentation is costly.

The camera can be a small 35mm or a larger 120 size. The larger negative size is preferred for enlargements. The 4 × 5 camera can be used if a wind shield is built around the bellows.

Avoid using a short-focal-length lens. Perspective distortion and a loss of quality could occur if large blowups are needed. Use a normal lens or a short

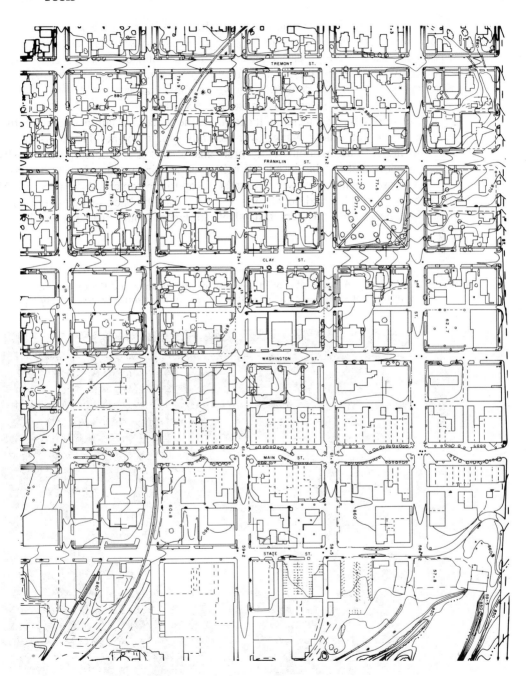

Photo 14.5 Example of a topographical map drawn from a vertical
photograph. (Courtesy of Aerial Services, Inc., Waterloo, Iowa.)

telephoto lens. Use the lens that will fill the frame of the negative with the subject. A good zoom lens will allow rapid framing of the subject without having to change lenses and making another pass over the target. A motor drive would allow many exposures while passing the subject. The newer automatic exposure cameras are useful in rapidly changing conditions; however, the aerial haze, or change in brightness as the altitude increases, may cause underexposure.

The aircraft that is selected will determine the success or failure of the shooting session. Try to get a slow, wings-over-the-body type of plane. The doors can be taken off these planes without safety problems. If this is a problem, they usually have a window that can be raised and held open by air pressure. It is still a good idea to wear seat belts and to secure a safety strap to the camera. A four-seater will allow the photographer additional room to move, and the back seat can be used to store equipment. Rule out very fast, sleek airplanes. Contrary to popular belief,

Photo 14.6 *A helicopter with the door removed provided the only view point to photograph the entire structure of Och's Museum on the side of Lookout Mountain.*

helicopters have a difficult time hovering in one spot for any length of time. The vibration increases and the motor overheats while hovering. Also, the cost to rent a helicopter is usually three to four times that of a plane. Thus unless there is some low (less than 500 feet) flying to do, stay with the plane.

It is essential that you plan your mission with the pilot before takeoff. Pick a good pilot, one willing to work with a photographer. An experienced pilot is definitely an advantage. To be successful, aerial photography depends on getting the aircraft into the proper position and the plane slowed to minimum speed. Know the objectives of the mission, what the photos will be used for, and for whom they are being taken. Also know what and where your targets are and have some idea of how they will look from the air. It is easy to get disoriented while in the air. If you have different altitudes to fly, start with the highest. It takes less time to descend than to climb. This planning saves money and eliminates guesswork once you are in the air.

Photo 14.7 *This aerial photograph shows the hotel at Reelfoot Lake State Park in West Tennessee, with the small-craft airfield in the background.*

Photo 14.8 *Images from a high vantage point on top of mountains or high-rise buildings can be often substituted for aerial photographs. (Courtesy of Oak Ridge National Laboratories.)*

It is difficult to hear and communicate with the pilot when you are in the air, due to the engine noise and the air rushing by. A set of hand signals will come in handy to direct the pilot, if necessary. Another idea is to use a headset which is voice activated. Use storyboards to plan your layout. Attention to detail and good communication with the pilot will solve most problems and ensure a good photo session.

TECHNIQUES

Try not to shoot while in a steep turn. The *g*-forces will make it difficult to control the camera, especially in a jet. With smaller, light aircraft, there will not be this problem. Also do not shoot when the aircraft is turning. The negatives will be

Photo 14.9 *A red filter should be used to reduce atmospheric haze and increase contrast with black-and-white film. (Courtesy of Aerial Services, Inc., Waterloo, Iowa.)*

reasonably sharp in the center but will lose sharpness toward the edges.

If the photographer has to shoot through a canopy or window, be aware of reflections, scratches, and dirt. Clean the window while on the ground. Use a black rubber lens shade on the camera as close to the window as possible to minimize reflections. Do not touch the window, however, because the engine vibrations will be transmitted through the camera and a slightly soft image will occur. Do not rest the upper body or arms against the aircraft. Again the vibrations will be transmitted through to the camera. Lean forward in the seat.

Since the plane is moving rapidly, use the fastest shutter speed possible. It is okay to shoot wide open since the camera will be focused at infinity. Tape the focus at the infinity setting to keep from moving it accidentally.

Photograph the subject as it is approached. If one tries to photograph a subject while immediately over it or past it, there will be difficulty keeping it in view. Keep in mind where the horizon is and keep the camera so that the viewfinder or camera body is parallel to it; otherwise, some adjustment or enlargement will be necessary in the darkroom. Have the pilot slow the plane when approaching the subject. He or she can do this by reducing the throttle, banking the plane slightly, and slipping toward the subject. This reduces engine vibrations and reduces image motion.

Some believe that special aerial film will give better results. This is not so. These films are designed for high-altitude, vertical photography and may require special processing techniques. If used in low-altitude, oblique work, there may actually be a loss of quality.

One technique is to underexpose black-and-white film from $\frac{1}{2}$ to $1\frac{1}{2}$ f-stops and to overdevelop the film 10 percent to increase the contrast. This helps make the lower-contrast aerial scene acceptable. Be sure to use a lens shade to reduce flare.

Some photographers recommend that a reflective reading be made on the ground from a gray card or use an incident reading. Others suggest that an averaged reading from the air is best. Still others say to do both and average the results. Whichever method is used, the technique should be tested before going on a vital mission.

Haze lies in the ultraviolet portion of the spectrum. This causes an excess bluish appearance in photographs. It also lowers contrast. Filters will help reduce haze if it consists of moisture. If the haze is pollution made up of solid particles, filtration will not help. Some advise increasing both exposure and development in an effort to compensate for this haze. Increased exposure results in more density but does not increase contrast. Increased development produces adverse results if carried too far. There is a point at which increased development begins to produce base fog, resulting in reduced printing contrast.

With black-and-white film a yellow filter will increase contrast. A red filter should be used if the haze is particularly bad or the plane is near or above 5000 feet. With color film, a 1A filter should be used, or a 2B filter if haze is bad. An HF-3 aerial filter can be used in lieu of the 2B filter. The characteristics are the same.

Infrared film will provide more haze penetration than will black-and-white film. When using black-and-white infrared films, the blue and ultraviolet radiation must be filtered by using a No. 25, No. 29, or No. 70 filter. With color infrared film, a No. 12 filter is used.

Filters can be used for special effects. A green filter will lighten the foliage. The polarizing filter is unpredictable, and it takes too much time to get it set in the air. An orange filter will enhance a sunset, and a star filter will add sparkled highlights to water or to point-source lights.

Try to shoot right after a cold front passes through the area. This provides for a crystal-clear atmosphere. A visibility of 15 to 20 miles is ideal. Haze is usually at its worst in the morning.

For even lighting, it is best to shoot between 10 A.M. and 2 P.M. The slanting

Photo 14.10 *Right after a cold front passes through an area, you will have a crystal-clear atmosphere in which to make aerial photographs. (Courtesy of Oak Ridge National Laboratories.)*

rays of early morning and late afternoon can add dimension to a photograph by using the shadows to provide depth. Cross-lighting can add shape to aerial subjects. Some clients like the graphic effects of extreme back lighting.

SUMMARY

The industrial photographer can enhance his or her usefulness by being able to produce aerial photography using small planes. Hand-held cameras are required, and vital to the success of the mission is using proper filtration and proper exposure.

Photo 15.1 (Courtesy of Oak Ridge National Laboratories.)

Chapter 15

Audiovisual Presentation Tips

OBJECTIVES

Upon completion of this chapter, you should be able to:

- Utilize AECT standards in title slide production.
- List uses where a company may need audiovisual productions.
- Explain how artwork is constructed.
- Give guidelines for photography, production planning, projection, writing, and audio.

INTRODUCTION

Audiovisual (AV) presentations have many uses in industry. They range from training, entertainment, company awareness, product promotion, corporate image, communications, employee motivation, to many other areas. Regardless of its use, there are many steps necessary to produce a good AV program, and many skills are required. For the photographer in a small industrial department, it may seem an overwhelming task to produce a program where you might have to be a photographer, producer, writer, narrator, and also perform all other duties required. When faced with this prospect, it is highly recommended that you purchase the Kodak publication *Images, Images, Images.*[1] It is *the book* detailing the process of the

production of a program. It is filled with good advice on how to proceed and lists many of the pitfalls to watch out for.

The following tips on AV production come from various sources and experience.

AECT STANDARDS

Several years ago the Association for Educational Communications and Technology (AECT) published a list of guidelines for its members to follow in making a presentation. It is included here in its entirety in slightly altered form.

1. Limit each visual to a single, unified idea.
2. Plan visuals so that their longest dimension will be horizontal. It is difficult to view vertically oriented materials in rooms with low ceilings.
3. Use upper- and lowercase letters. Any copy of more than five or six words will be more readable if both capital and lowercase letters are used instead of capitals only.

Diagram 15.1 *Type case.*

4. Select a good, readable alphabet style in which all letters are easily recognized with a minimum of confusion. One of the Gothic-type sanserif typefaces, such as Helvetica, Helios, Kabel, Futura, Tempo, or Venus, might serve as a model.

Diagram 15.2 *Type style.*

Example of
Old English type

Example of
Sans Serif text

5. Use a plain, vertical letter style without embellishment except where emphasis or emotional impact is desired, and then exaggerate the size. Avoid script letter styles because they are difficult to read. Use italics sparingly, if at all.
6. Assuming an approximate format $8\frac{1}{2} \times 11$ inches in size, limit your smallest lettering to a minimum of $\frac{1}{4}$ inch in height, $\frac{1}{32}$ inch in thickness of line, and at least $\frac{3}{8}$ inch in the space between lines. Often, visuals have to be presented under less-than-ideal conditions; conse-

quently, the suggested minimums are conservatively high.

7. Letters should be about as wide as they are high (except for obviously narrow letters such as the capital I, E, L, etc., and the wide letters M and W), of medium weight (very heavy letters are as difficult to read as very light letters), and of approximately uniform thickness throughout.

Diagram 15.3 *Type space.*

8. Space lettering so that the areas between letters are adequate for greatest legibility and appear equal for uniformity.
9. Allow a $1\frac{1}{2}$-letter width for the space between words and three widths between sentences. Too much or too little space makes reading difficult.
10. Use strong light–dark contrast for all lettering—either black or very dark letters on a light-colored background or white or bright-colored letters on a dark background.
11. Allow an adequate margin (at least $\frac{1}{2}$ inch) between lettering and the inner edge of the mount (overhead transparency) or the outer edge of the area to be photographed (2×2 slide).
12. Picture symbols (illustrations) must be large enough and obvious enough to be easily recognized by their intended audience.

Diagram 15.4 *Graphic illustrations.*

13. Assuming the same $8\frac{1}{2} \times 11$-inch format mentioned previously, picture symbols should be at least one-fourth the size of this overall area unless they are extremely simple.
14. Make drawings and diagrams bold and simple. Include only essential details.
15. Picture symbols should be outlined with a heavy line at least $\frac{1}{16}$ inch

thick. Necessary details can be added in thinner lines since they should appear less important. But avoid using too many thin lines because they may not reproduce well and may actually confuse the clarity of the illustration when viewed from a distance.

16. Generally speaking, maximum light–dark contrast is advisable for all lines—black or near black on a light background. Contrary to what was said of lettering, white drawings on a dark background are sometimes difficult to interpret because people are not accustomed to seeing illustrations in negative form and cannot quickly make the transposition.

17. Color is an important adjunct to most visuals, but it should usually be applied in flat areas rather than in graduated tones or elaborate shadings.

Photo 15.2 *This artwork was produced by painting an animation ''cell'' after using 8 × 10 ortho film to record the line art. The cell was placed over a reproduction of a painting to make an audiovisual slide.*

Diagram 15.5 *Television format.*

18. Use contrasting colors that harmonize. Color combinations that clash tend to annoy the audience and interfere with clear perception of the message.

ARTWORK

As mentioned above, artwork needs to be constructed simply to be effective. This also holds true for photography. When making drawings or type slides, it is a good idea to standardize on a board size. Ten by 12 inches is a good size to use. It is close to 35mm in format and the card stock can be placed in a file cabinet when completed.

When putting copy on the card stock, allow room for a "bleed" area. This is a safety area surrounding the information area. Allow the information area to be 6 × 9 inches with a bleed area of 7 × 10 inches on a 10- × 12-inch stock size. If the work is planned for television, the usable or information area is about $4\frac{1}{2}$ × 6 inches. Remember that the corners are oval on a TV screen and should not be used for type or other information.

If a typewriter is used, try $3\frac{1}{2}$- × 5-inch cards for the lettering. The information should not exceed 3 × $4\frac{1}{2}$ inches. Depending on type style, pica covers 45 spaces and elite covers 54 spaces.

Photo 15.3 Multiple exposure through colored gels and a star filter created this special effect.

Titles should be twice the size of the letters. Plan a maximum of 10 lines of text with no more than 24 characters per line. Five lines and 20 words would be better.

A *word of caution:* Do not confuse the audience at the beginning with overly inventive titles. This could cause them to "tune" the speaker out.

AUDIO

Audio is one area that receives less effort than the visuals. It should receive more. It has been found in various studies that a poor audio track can impede the learning process. A well-designed program should eliminate as much "noise" as possible or risk a turnoff of the audience. This is one area in which a good professional voice is an asset. Try to contract this phase of the production to a radio station or other production house with the proper equipment and talent. For a corporate or business show a single, mature voice with "newscaster" quality is generally best.

Background music is an asset to a production. Use only copyright-free music or music from a library source. Using the latest LP will get the producer in a lot of trouble in the copyright area. Sound effects can enhance a production.

When it is time to run the show, put the audio on a different circuit than the projectors. This will eliminate some of the noise in the circuit created by projectors.

PHOTOGRAPHY

Always use a duplicate for a final show. Keep the original in a safe place so that duplicates can be made in case of accidents. Never carry the slides in your luggage when traveling. If the bags are lost, there will be nothing to show at the presentation. Make sure that the photography is properly exposed. Inconsistency in exposure is easily noticed in a sequence of slides. Keep all the slides horizontal in format. Verticals are hard to fit on the screen and next to impossible to fit on a TV format.

Try to work from a "shooting script." This will eliminate a lot of guesswork. However, do not follow it so precisely that creativity is lost. One of the biggest mistakes is undershooting. Look for creative angles, lighting, or situations, as well as what was planned. Being creative might just save a boring show. Ideas on creativity are presented in Chapter 16.

When mounting the slides for the program, use plastic or glass mounts. These are less likely than cardboard mounts to jam.

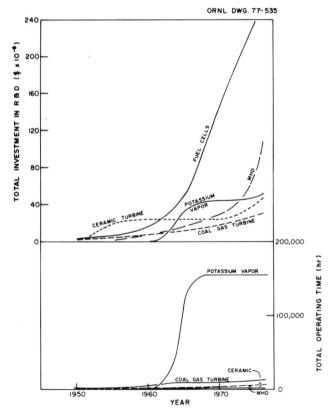

Photo 15.4 Vertical drawings are difficult to read when shown on a horizontal screen. (Courtesy of Oak Ridge National Laboratories.)

PLANNING

There are very few programs that are overplanned. Generally, they are under-planned. The time spent in planning will be well worth the effort in the long run, so do not neglect this aspect of production. It is wise to bring photographers in as soon as possible. Too many times they are left out of the planning process, and the program suffers from lacking their creative ideas. The creative photographer has the ability to visualize ideas as images that have impact.

O'Neill states: *"The three key words* of good slide shows are: Analyze, Organize, Visualize. *The two key words* are: Preview, Review. And *the one key word* is: Prepare. Your audience determines what to cover at the beginning, and your message determines the end. It's what's in between that takes thought."[2]

The following nine-point outline in planning a production is pretty well accepted as standard.

1. Define your objective(s).
2. Analyze your audience.
3. Make a content outline.
4. Review your progress.
5. Identify a treatment plan.
6. Write a script.
7. Plan your slides (storyboard).
8. Edit your slide presentation.
9. Prepare for a smooth presentation.

Plan the program so that it moves. Try not to have a slide on the screen for more than 5 seconds unless it is necessary. If the visual has a lot of information on it, it is better to make several slides of it than keep it on the screen. The visual material should get the message across quickly. It is a good idea to leave a slide on the screen twice as long as it takes to read it silently. Vary both the narration and screen pacing; otherwise, you could lull the viewer to sleep. A presentation should be long enough to do its job and no longer; therefore, there is no rule as to length of a program or how long an image is on the screen.

Good visuals stimulate interest and clarify the message. Visuals can take different forms, such as:

1. A picture sequence
2. Words on the screen
3. Symbols
4. Charts and diagrams
5. Action sequences

Photo 15.5 *An object combined with letters makes an effective opening for a program.*

Photo 15.6 *Clarity and understanding is enhanced by using labels on complicated objects. (Courtesy of Oak Ridge National Laboratories.)*

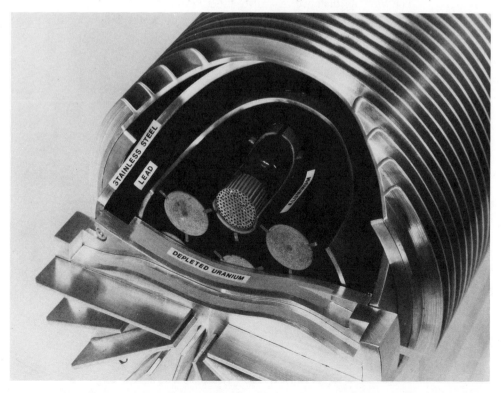

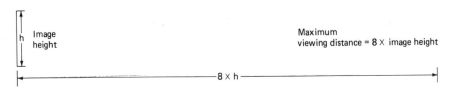

Image
height

Maximum
viewing distance = 8 × image height

8 × h

Diagram 15.6 *Viewing distance.*

PROJECTION

When designing visuals, the viewing conditions should be taken into consideration. If there is some ambient light, the visuals should be viewed with this in mind when planning them; otherwise, some important information may be lost.

There is a rule on viewing distances that is a standard. Unfortunately, it is too often forgotten. The accepted standard for viewing distance and subject size is that the viewing distance equals eight times the height of the projected image. What this means is that if a person is 24 feet away, the image on the screen should be at least 3 feet in size.

Letters within this area should be at least $\frac{1}{25}$ of the total image area to be easily read with the ideal at $\frac{1}{17}$. The maximum viewing distance for TV is 12 × the horizontal screen size. The viewer should also be within 45 degrees of perpendicular to the screen.

The viewing distance may also affect the viewer. Audiences may be uncomfortable being closer than a distance equal to twice the height of the image. If

Diagram 15.7 *Viewing angle.*

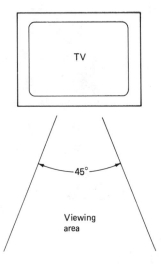

TV

45°

Viewing
area

possible, use rear screen projection for the visuals. The beams of light in a room may distract some viewers.

When checking the program in a dry run, have a spare lamp or two. Check that the audio is not too high and that it can be heard in the rear of the room. It would also be wise to check the circuits for power requirements. Several projectors and a dissolve may be enough to blow a fuse. That would not be a wise thing to have happen during a program.

WRITING

Good writing is written to be heard, not read. Edit the text out loud. It should be concise and to the point. Use short sentences and words that are not too difficult. Avoid unnecessary words and make full use of variety. When in doubt, simplify. Remember the target audience when writing. Try to use a fresh angle to keep your audience's attention.

Start with the message, then add the visuals necessary to complete the program. Do not take a bunch of slides and try to write a script around them. A mixture of visuals, including title slides, graphics, and special effects, will maintain an audience's attention. Organization and simplicity are the main ingredients for producing a good script and an effective slide presentation. However, these will not make a photographer an expert on the first try. They will help to create a successful slide show.

SUMMARY

Plan, plan, and plan are the guidelines needed for AV productions. Few productions are overplanned. Considerations are needed in all areas, from audio to writing, if a smooth presentation is to take place. Following the guidelines presented, the industrial photographer can produce a program of which to be proud.

REFERENCES

1. Kenny, Michael F., and Schmitt, Raymond F. (1981). *Images, Images, Images*. Rochester, N.Y.: Eastman Kodak (out of print).
2. O'Neill, Jerry (1984, May). I see what you mean: communicating effectively with slides. *Photomethods*, pp. 23–25.

Photo 16.1 Instructions to a welder provides graphic opportunity for the photographer. (Courtesy of Oak Ridge National Laboratories.)

Chapter 16

Creativity

OBJECTIVES

Upon completion of this chapter, you should be able to:

- Define creativity.
- Understand the process of creativity.
- Relate Zen to creativity.
- Be able to perform various exercises to stimulate creativity.
- Stimulate awareness.
- Create ideas and enhance intuition.
- Foster relaxation.

INTRODUCTION

Every year billions of dollars are spent on photographs for the purpose of advertising, portraits, and illustrations in magazines and on billboards. Editors are forever searching for the "creative" photo, the one that has a unique quality. It is a very elusive quality, one that is difficult to define and still more difficult to teach to aspiring photographers.

Creativity is very important to the industrial photographer. Too often the industrial photographer is faced with the challenge to make an award-winning photograph from a pile of junk. Too often the industrial photographer, or for that matter any photographer, gets lazy and produces the same pictorial quality time and again.

It is only when the photographer can extend his or her vision beyond the ordinary that a truly creative photograph is made. For that reason a chapter on creativity is included. It probably should be placed first in the book; however, it is last so that the basic principles could be learned first. Then by extending your vision, you can take the basic processes and make a creative image.

PHOTOGRAPHER'S DEFINITION

The basic concept that most photographers follow concerning creativity is that it is a process rather than an entity unto itself. We will look at this process in the next section. "The creative process is one which solves some problem in an original, imaginative and useful manner."[22] "Creativity basically has to do with mental freedom, being able to play with possibilities, consider options and alternatives and generate new and exciting ideas."[19] Creativity, then, is the search for something new, and its essence is shaping old elements into a new photograph. "Creative photography involves the most skillful use of technical means to make the reader see a subject as the photographer sees—and feels—it."[29] There are then two main elements in being a creative photographer, a probing eye and the technical skills to accomplish the vision in the mind's eye. A creative photograph "makes us look freshly at something which is commonplace."[2]

Creativity is a skill that can be learned by studying the processes and products of other creative minds. However, it does not mean copying others, nor is it "shooting everything on 35mm infra-red Ektachrome with colored fluorescent lights, and slightly out of focus."[23] Rather it should be a synthesis of others' ideas into your own. These ideas are created when we learn to observe. This is one of the steps in the process of creativity which was inherent in virtually all of the photographer's definitions of and statements pertaining to creativity.

Another aspect of creativity that photographers should recognize is the use of imagination. "Imagination is the ability to create with the mind. In photography, imagination enables the photographer to see 'differently'.[6] This imagination is spurred on by intuition, an "immediate flash of visual inspiration."[3] This is the process of Zen, acknowledged by many photographers as an integral part of the creative process. "Creativity can be characterized by an intensity of awareness or heightened consciousness. The moment when lightning strikes. Sometimes known as the intense encounter."[11] "Conceptualization and execution of any creative form is the function of the human psyche, the imagination coupled to the hand and the eye."[5]

"The photographer who can see beyond the subject's existing visual appearance and knows how to affect its pictorial appearance, can create exciting pictures from seemingly dull subject matter."[17] This imaginative seeing, this learning to see, is the process of creativity.

Photo 16.2 Creativity is shaping common elements into a new photograph.

Photo 16.3 The photographer who can see beyond the subject's visual appearance is one step into the process of creativity. (Courtesy of Oak Ridge National Laboratories.)

PROCESS OF CREATIVITY

The creative individual must have a sensitivity to problems, have the fluency to generate a number of ideas, and be flexible and original in his or her thinking. Curiosity as well as a strong desire to create is also vital. "Every frustration is born of a problem that requires creativity to solve."[28] So isolate yourself and let the ideas flow. Visualize the result and follow up with hard work.

Photo 16.4 *A sense of humor is a creative attribute. The photographer recorded the board of directors singing the blues when the competition caught them with their pants down. (Courtesy of Douglas Benton.)*

"Challenge operates as a catalyst to creativity"[31]; inspiration is the fuel and work the motor. But all three are "meaningless in the absence of an inner drive . . . and that means letting what is essentially subconscious take over as far as your creative efforts are concerned."[31] There is no formula for creativity. It requires attitudes such as effort, experimentation, noncomplacency, having a positive attitude, and within reason, being a nonconformist.

Some psychologists, unfortunately, disallow any connection with the spontaneous formation of ideas by the subconscious during periods of meditation or relaxation. In a letter to the editor, one group outlined a five-step plan to creativity: "First select an area of interest. . . . Second, select . . . culturally relevant problems. . . . Third, adopt a problem-solving perspective. . . . Fourth, control your environment. . . . And Fifth, control and change your behavior."[7]

Of all the plans and processes to follow in developing creativity, Shepard and Meyer[32] have a workable one that fulfills the elements with which most photographers agree in whole or in part. The creative individual must have attributes such as an insatiable curiosity, an instinctive delving beyond the obvious, a strong will, an untiring drive, enthusiasm, and a sense of humor. These qualities are the combustible elements from within that make their ideas explode in all directions. The process needs direction to channel these ideas. First, one must gather a lot of information, both general and specific, about a topic. This provides the fuel for the subconscious to work on. Second, relate this material to the problem at hand. Think about it, examine each part in detail. Third, relax, forget about the problem, meditate, or take a coffee break. This is the "incubation" period needed for the subconscious to arrange the information into a new idea. Fourth, the birth of the idea is in the sudden flash of intuition or inspiration. Fifth, the idea must be shaped into usefulness by action. A photographer must now make the picture to resemble the visualization within the mind's eye.

ZEN RELATIONSHIP

In the process of creativity, it seems that a necessary step is to relax and let the subconscious mind rearrange the patterns of thought. A great many photographers have used the practice of Zen or meditation to further this process. Minor White, a photography instructor at the Massachusetts Institute of Technology (MIT), used the book *Zen in the Art of Archery* by Herrigel as a basic text for his classes. White taught that "seeing" is a part of photography, and to see in a Zen way, technical knowledge is not enough. Rather, it is to relax and experience the object for what it is. As soon as we think about, label, or analyze it, we have lost its true meaning. White is quoted as saying: "Be still with yourself until the object of your attention affirms your presence."[10]

White is not the only photographer to recommend Zen as an aid to photography. Patterson and Allen recommend Franck's book *The Zen of Seeing*, and Nelson recommends Herrigel's book. To learn to see, one must practice so that the equip-

ment and technique are no longer a concern to the photographer. ''When it becomes a true extension of yourself, it will cease to be an impediment to your vision.''[25] Then one must be in a relaxed state and contemplate the subject, which means ''working in isolation.''[25] This echoes Wignall's concept of ''isolationism,'' which is discussed in a later section.[36] This is essentially what Herrigel says about archery. Allen Salomon, in his book *Advertising Photography*, describes it as a visual *tai chi*, a moving meditation, or flowing with the universe. Edward Weston wrote about his ''Pepper #30'' that it ''takes one beyond the world we know into an inner reality— the absolute with a clear understanding, a mystic revealment.''[34]

Photo 16.5 *Creativity and the practice of Zen are both exercises in simplicity. (Courtesy of Oak Ridge National Laboratories.)*

EXERCISES

The survey of literature shows two areas where exercises would be helpful in promoting creativity for photographers. One is in the visual area, which promotes seeing or the visualization of an image, and the second, the intuitive experiments which promote the generation of creative ideas.

Visual Awareness

Visual awareness is the ability of the photographer to observe the details in the surroundings. Photographers must be able to see and recognize unique subject material for their camera if they are to be considered creative. "Good seeing begins

Photo 16.6 To be creative, the photographer must be able to recognize unique subject material. (Courtesy of John J. Kommelter.)

with careful observation''[26] and ''keen observation.''[6] Since the exercises that follow deal with observation in some way, I will try to categorize them in areas of similar thought, although some may be used in other exercise categories.

Observing. One of the photographer's first tasks is to observe. You should investigate your surroundings by photographing a series of numbers, or arrows, spirals, circles, or repetitive patterns. Look for details within your present photographs; isolate and print them. This will allow you to develop the ability to see compositions and patterns in groups of objects. ''Good visual design in your photographs comes with careful observation.''[26]

You can enhance your observation by studying the photographs of other photographers. One should not become the ''disciple'' of another but develop your own style. Helprin[14] suggests the following exercise.

Photo 16.7 *Good observation includes looking at details.*

Go through all your existing photographic work and divide it into the following categories:

1. Pictures . . . in which the visual excitement has been ''captured'' or recorded, rather than created.
2. Pictures . . . in which you have deliberately affected the visual attributes of the subject matter for purposes of pictorial excitement.
3. Pictures . . . which depict . . . visual aspects that were not visible until you purposely made them visible through the medium of photography.

Each category is a visual mode of observation. The category with the least amount of photographs is the one that you need the most work in developing.

Visual Abstractions. Abstracting is ''recognizing both the basic form of something and the elements that make up that form.''[26] Take a series of visual abstracts and photograph them as ''shapes, forms or designs but not as objects.''[21]

Photo 16.8 Visual abstraction is photographing shapes, forms, and designs. (Courtesy of Oak Ridge National Laboratories.)

Try to make them "visual puzzles." In the portrait field, incorporate "pure design—shapes having no representational association with a person."[2] Experiment with form and texture, and form and color, respectively. Experiment with changing patterns, such as shadows and reflections.

Similar to abstracting is moving in close to the subject. By moving in close we are selecting the parts that best express the character of the subject or the meaning of the event.

Simplicity. By learning to abstract we learn to separate the parts from the whole. All photographers should develop this ability to isolate the elements. "Look at the parts singularly for their own photographic potential and then seek other combinations if you wish."[35] One exercise is to try to break a subject down into

Photo 16.9 *Creative photographers advocate the use of simplicity in photography.*

components and isolate the most salient features that define the subject. Wignall calls this ''isolationism.''[36] ''Nature observes the rule of simplicity, which means that nothing in nature is more complex than it has to be. . . .''[26] In photography this means including only what we must to give order to the photograph. Photographers advocate the use of simplicity in photography. The simplification of the idea is fundamental to creating an understandable photographic message.

Mapping. An approach to photographing a subject is to group ideas into a theme, a series of pictures, or variations of the subject. Circle the subject, move in, and use high and low angles and close-ups. ''This assignment should give you some

Photo 16.10 *''Mapping'' means looking for unique angles other than at eye level. (Courtesy of Dwight Dake.)*

feel for the variety of possibilities contained in a single subject.''[21] Another variation is to map a subject but never use an eye-level view. Select different viewing angles. In connection with themes, Helprin[17] gives the following exercise:

1. Choose a subject.
2. Take six different shots of the subject.
3. Choose another subject and repeat the six-shot procedure.
4. Continue the exercise until you have shot six different subjects.

Your goal is to produce at least one exciting picture of each of the six different subjects. Repeat this exercise until your goal is accomplished.

Photo 16.11 *The exploration of themes such as patterns and rhythm stimulates seeing.*

Kodak's *Photo Explorations* contains 101 exercises in which the photographer explores a theme. It is recommended that a roll of film be exposed for many themes, such as textures, shadows, reflections, distortions, scenics, pattern, and rhythm. Do not become overwhelmed by the multitude of possibilities; rather, make a choice and explore it fully. Helprin[16] suggests the following exercise:

Choose a common, ordinary subject that appears to be visually uninteresting. Then using any visual modifier that affects the appearance of the subject in a manner that can be seen before the picture is taken, produce at least five pictorially exciting photographs of the subject.

The visual modifiers include light (quantity, quality, and direction), color, view point, environment, composition, and optical modifications. It is suggested that you place the subject in an unusual environment, one that takes the subject out of context.

Photo 16.12 This editorial photograph was used as a visual symbol to illustrate an article entitled "Janitors, the Forgotten Employee." (Courtesy of Oak Ridge National Laboratories.)

Symbols. An exercise similar to mapping is developing photographs with symbolic meaning. We think and communicate via symbols. Thus a theme that is expressed with a clear and concise symbol is easier to bring to film. However, we must avoid the cliché. Since symbols must be learned, the task is for the photographer to create metaphors that the viewer will understand. The photographer should practice techniques to strengthen the symbols he or she want to emphasize.

Along these same lines, one might consider the realm of fantasy. Try to photograph someone acting out fantasies or photograph yourself using mirrors or self-timers. Also, try exercises to evoke a predetermined and specific emotional response on the part of the viewer or create a photograph that depicts a specific emotion. A novel approach would be to create animate photos from inanimate objects, and vice versa.

Sideways Thinking. By combining observation and the use of symbols we have *sideways thinking* and *divergent thinking*. Thinking sideways "is simply a matter of building up a mass of visual information about your subject matter from

Photo 16.13 *Breaking the rules by "panning" is one way to think sideways.*

observing it from many points of view.''[26] You think ''of all the deliberately illogical things you can. This loosens up the brain cells quite a bit and helps you think in new patterns. . . . Think backwards or upside down—think illogically, that is.''[12] This allows us to ''create a photograph that purposely breaks one or more of the traditional concepts concerning the psychological, visual or physical nature of a photograph.''[13] List the standard rules of photography and then go out and break them.

Breaking the rules is one of the admonitions of many advanced photographers. To do this, one must know what the usual procedure or rule is and how it affects the visual message. Then change these rules, but only one at a time. You can then learn under what conditions a change from the normal is effective. Similar to visual abstraction, the photographer uses incongruities, surrealism, cubism, or futurism to break the rules of photography. Shoot impulsively, allowing the subconscious to direct the camera. Only when the photographic results are viewed do we consciously analyze the images. If something attracts us, we should go back and investigate this area or subject more thoroughly. Shoot, set up variations, repeat the shooting. Varia-

Photo 16.14 *Using special effects is one method of enhancing visual abstraction.*

tions appear spontaneously. "The photographer . . . will be borne along on a freely flowing stream of associations. . . ."[24]

To concentrate our thinking, we need to practice our observations in small areas. Lock yourself in your bathroom until you have made 36 exposures on film of 36 different subjects. Outdoors, explore a subject or area by staying in the same spot. Search your backyard trying to keep your eyes and your mind open. Helprin[15] has the following exercise:

> Produce 12 pictorially exciting photographs taken within a radius of 50 feet from the front door to your apartment or house. You must accept the subject's existing state and may neither move the subject matter nor change the lighting upon it.

Intuition Enhancement

These exercises deal with the mental aspect of creating photographs, or images. Mental exercises are psychological in nature. "The limits to our creativity are within, not without."[9] When we try to confine psychological exercises to photography, as

Photo 16.15

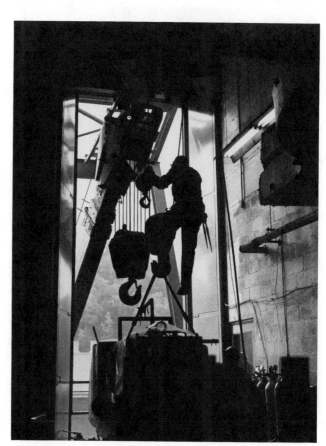

stated by photographers, we have indeed a limited number of choices. They fall into the areas of ideas, relaxation, and intuition, although intuition is the means by which the idea is realized, as evidenced by the use of Zen.

 Ideas. In the realm of physical photographic manipulation, do not copy others' techniques directly. ''Technical competence cannot significantly enhance one's vision.''[25] Take others' ideas and shape them into new ones by adapting ideas from other periods; modify them by altering color or form; magnify by exaggerating a part of the subject; minimize by reducing the subject and altering perspective; or combining several elements into a new ''formula.'' You can also ''substitute, re-arrange and reverse.''[27]

 In using the ideas and observations around us, an open mind is as necessary for success as an open eye. We also must be able to visualize with the inner mind's eye how a photograph will appear when finished. ''Finding unique ways to reveal these hidden harmonies in their simplest form rests largely on your ability to visualize a given scene . . . as a finished photograph.''[36]

Photo 16.16

Photos 16.15 and 16.16
Darkroom manipulation is not creative in itself. You must first start with a creative image and allow darkroom work to enhance it. (Courtesy of Oak Ridge National Laboratories.)

Intuition. To be in harmony with the subject, ideas must come from an inner source. Staubach reports that Karen Szekessy, a noted German photographer, creates artistic ideas from her dreams.[33] However, most photographers prefer to use the term ''intuition'' for this. This is visual perception. Too many photographers do not use their mind's eye. Visual perception involves all the senses, plus memory. The visual process is more important than technical know-how. Knowing about perception before taking a photograph helps because the actual taking should remain intuitive and open to inspiration.

Use ''imaginative expertise: an almost intuitive insight or creative sense. . . .''[4] Photography is highly intuitive and instinctual; even the best technique is never enough without inspiration. ''It's important that you develop an intuitive feel. . . .''[36] ''The creative process works partly from intuitive flashes of insight, partly from practice, and partly from just plain work.''[3] This leads us to the Zen that many photographers use in their practice, via the relaxation exercises.

Photo 16.17 *Visual perception involves all the senses. Photographs are just waiting all around us if we open our eyes and mind.*

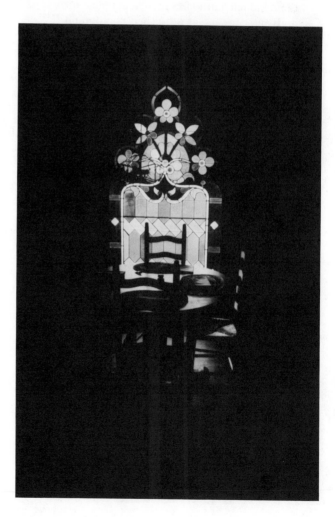

Relaxation. White demanded total concentration from his students and he taught them relaxation. White asked his students to photograph the essence of a place and then to photograph its equivalent. "In attempting to capture the spirit, personality, or essence of a person, animal, or place, look carefully and, if necessary, wait."[35] In a state of contemplation, one has to be relaxed if one's subconscious is to operate. "The idea is to look at something for a long time without conscious concentration. This must be done in a relaxed atmosphere . . . with no feeling of urgency."[1] Before photographing, sit or lie down close to the subject and try to erase everything from your mind except the subject. Concentrate. If you see nothing, change your position. Then do it again with a camera. The reasoning behind these suggestions is that your mind needs practice in forming visual images. "Find a quiet place and relax with your eyes closed." Imagine a TV set with an image on the

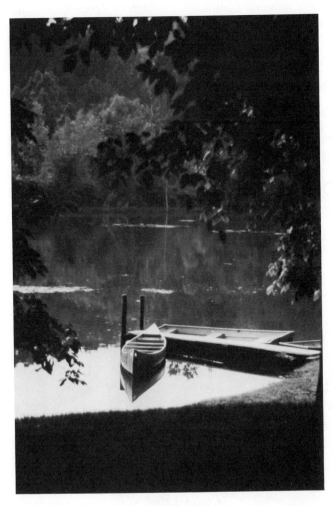

Photo 16.18 One has to be in a relaxed state of contemplation if one's subconscious is to operate.

screen. Change the image, move it, change its colors, taste it, feel it, and smell it. "Usually I get an immediate flash of inspiration. . . . Remove yourself for a time from the issue, and let the mind relax . . . through physical exercise and meditation."[3]

Patterson gives a three-step process to increase the use of intuition. First, schedule regular periods for relaxation and photography. Sit down, breathe deeply, using a progressive relaxation exercise similar to the ones found in self-hypnosis books. Empty your mind. Then pick up your camera. Stay relaxed and observe. Simply enjoy yourself. The second week, continue the first week's exercise, but this time choose a subject. Relax, then focus your eyes on successive details. Add imaginative questions such as: How would it feel if you drove an auto over this subject's surface? Use many questions by thinking sideways, as discussed earlier. The third week add to the first two your emotions on the subject. "You will see better when you understand why you are emotionally attracted to some objects, colors, and shapes, and repelled by others."[26]

Photo 16.19 *Walks in nature provide a means of freeing the mind.*

Photo 16.20 *(Courtesy of Tennessee Tourism Development.)*

SUMMARY

To summarize the many views discussed would be to repeat the many divergent views that have been presented in the body of this chapter. However, Mortensen gives the following four rules that are very applicable to a photographer's growth.

First, get busy on something else when your imagination fails. By worrying about the problem, you fail to relax and allow the subconscious to give you the creative answer.

Second, do not flatter yourself into thinking that this piece of work is the ultimate. This does not lead to other creative paths.

Third, seek finer things. It is only by uplifting thoughts that one's inspiration operates.

Fourth, "learn about the art of photography . . . in silence and solitude." In silence you will find peace; in solitude you will find yourself. "In silence and in the solitude things assume their proper perspective, personal issues fade away, and the great deliberate rhythms of nature become manifest. . . ."[24]

REFERENCES

1. Allen, J. J. (1978, July). Exercises in visual awareness II. *The Rangefinder*, pp. 33–86.

2. Burrell, F. (1980). A creative approach. In *Professional Portrait Techniques*, pp. 108–115. Rochester, N.Y: Eastman Kodak.

3. Carroll, D. (1980). *Focus on Special Effects.* New York: Amphoto.

4. DuBois, W. W. (1983). *A Guide to Photographic Design.* Englewood Cliffs, N.J.: Prentice-Hall.

5. Ericksenn, L. (1977, February). Looking/seeing, the difference is what photography is all about. *Camera 35*, p. 25.

6. Feininger, A. (1952). *Advanced Photography, Methods and Conclusions.* Englewood Cliffs, N.J.: Prentice-Hall.

7. Forest, J. J., and Lipson, S. (1984, April). Defining creativity (letter to the editor). *Creative Computing*, p. 6.

8. Franck, Frederick (1973). *The Zen of Seeing.* New York: Vintage.

9. Grundberg, A. (1983, June). Getting past the cliché. *Modern Photography*, pp. 72–75.

10. Hall, J. B. (1978). Minor White: rites passages. *Aperture*, p. 122.

11. Hampel, A. (1984). *American Photography Showcase* (Vol. 7). New York: American Showcase.

12. Hattersley, R. M. (1979, February). How to get ideas. *Popular Photography*, pp. 117–234.

13. Helprin, B. (1975, March). Breaking preconceptions. *Petersen's Photographic*, p. 8.

14. Helprin, B. (1978, May). Visual encounters of the third kind. *Petersen's Photographic*, p. 22.

15. Helprin, B. (1978, June). Visual awareness. *Petersen's Photographic*, p. 18.

16. Helprin, B. (1979). *Photographic Self-Assignments.* Los Angeles: Petersen.

17. Helprin, B. (1981, October). Seeing pictorially: ordinary subjects, extraordinary pictures. *Petersen's Photographic*, p. 16.

18. Herrigel, E. (1971). *Zen in the Art of Archery.* New York: Vintage.

19. Ironson, D. S. (1984, May). Stress the creative process. *International Television*, p. 18.

20. Kodak (1978). *Photo Explorations.* Rochester, N.Y.: Eastman Kodak.

21. Lovell, R. P., Zwahlen, F. C., Jr., and Folts, J. A. (1984). *Handbook of Photography.* North Scituate, Mass.: Breton.

22. Leach, R. (1982, April). In sight. *The Rangefinder*, p. 4.

23. Martin, D. E. (1976, June). Creativity in industry. *The Rangefinder*, pp. 33–34.

24. Mortensen, W. (1936). *Monsters/Madonnas*. San Francisco: Camera Craft.

25. Nelson, N. (1978, February). Learning to see. *Camera 35*, pp. 28–68.

26. Patterson, F. (1979). *Photography: The Art of Seeing*. New York: Van Nostrand Reinhold.

27. Pinney, R. (1962). *Advertising Photography*. New York: Hastings House.

28. Rickard, M. (1984, May). Desire—the source of creativity. *The Professional Photographer*, p. 68.

29. Rothstein, A. (1956). *Photojournalism*. New York: Amphoto.

30. Salomon, A. (1982). *Advertising Photography*. New York: Focal Press.

31. Scully, J. (1983, May). Seeing pictures. *Modern Photography*, pp. 28–60.

32. Shepard, H., and Meyer, L. (1960). *Posing for the Camera*. New York: Communication Arts.

33. Staubach, H. W. (1977, August). Karin Szekessy: photographed her dreams. *Leica Fotografie*, pp. 162–164.

34. Thornton, G. (1976). Edward Weston—a troubled master. In E. Brash (Ed.), *Photography Year 1976*, p. 67. New York: Time-Life.

35. Varney, V. (1977). *The Photographer as Designer*. Worcester, Mass.: Davis.

36. Wignall, J. (1984, July). Isolationism. *Studio Photography*, pp. 48–52.

Index